CREATED BY KRITZELPIXEL

LEARN TO DRAW MANGA

Hi, I'm KritzelPixel, and I hope you enjoy this book. Best of luck!

ZEITGEIST·NEW YORK

WELCOME TO: LEARN TO DRAW MANGA— IT'S FUN!

Fun is the operative word here. Hi, my name is Isabel, also known as KritzelPixel, and I present you with my latest book.

I developed this idea alongside my community of friends, fellow artists, and fans of my earlier work. It makes an excellent addition to my more skills-oriented books on learning to draw.

This book was inspired by my beginnings as an artist, when I discovered my love for art by copying and tracing my favorite manga heroines. I quickly got the hang of it, which motivated me to dive deeper and hone my skills even further. I loved the process, and now I want to inspire you to do the same.

Art doesn't require talent; it only needs to bring you joy.

So, I hope you'll enjoy learning to draw manga characters—in a playful and fun way!

Isabel Zimmermann aka KritzelPixel

CONTENTS

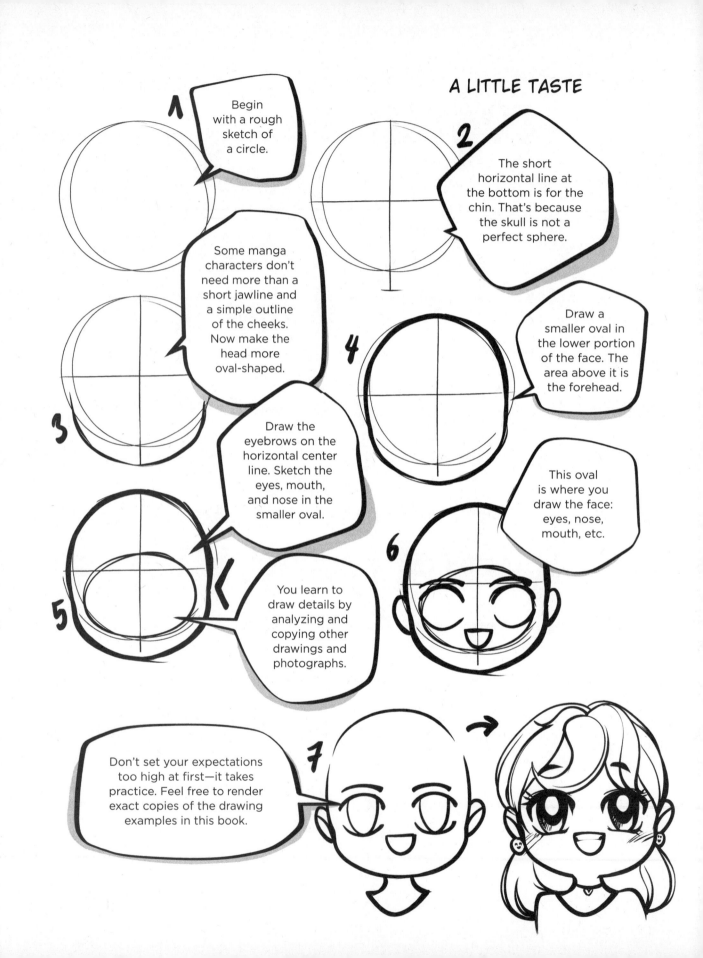

A LITTLE TASTE

1 Begin with a rough sketch of a circle.

2 The short horizontal line at the bottom is for the chin. That's because the skull is not a perfect sphere.

3 Some manga characters don't need more than a short jawline and a simple outline of the cheeks. Now make the head more oval-shaped.

4 Draw a smaller oval in the lower portion of the face. The area above it is the forehead.

5 Draw the eyebrows on the horizontal center line. Sketch the eyes, mouth, and nose in the smaller oval.

You learn to draw details by analyzing and copying other drawings and photographs.

6 This oval is where you draw the face: eyes, nose, mouth, etc.

7 Don't set your expectations too high at first—it takes practice. Feel free to render exact copies of the drawing examples in this book.

CHAPTER 1
INTRODUCTION TO DRAWING

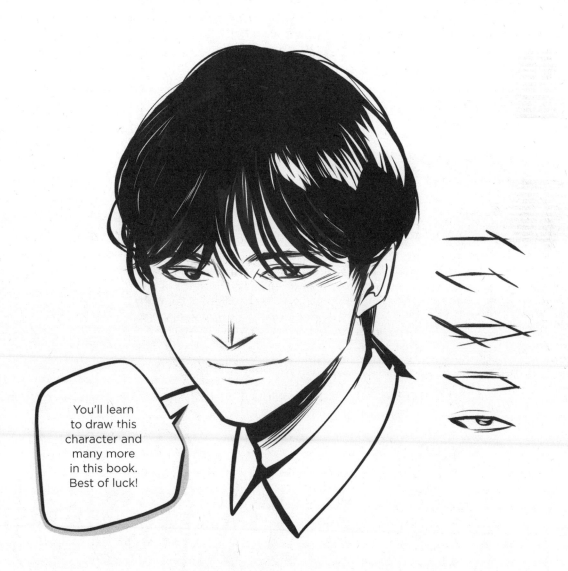

You'll learn to draw this character and many more in this book. Best of luck!

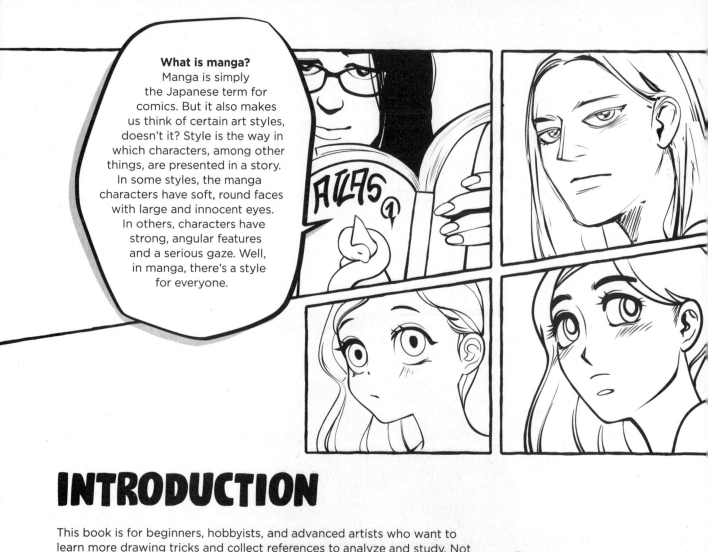

What is manga?
Manga is simply the Japanese term for comics. But it also makes us think of certain art styles, doesn't it? Style is the way in which characters, among other things, are presented in a story. In some styles, the manga characters have soft, round faces with large and innocent eyes. In others, characters have strong, angular features and a serious gaze. Well, in manga, there's a style for everyone.

INTRODUCTION

This book is for beginners, hobbyists, and advanced artists who want to learn more drawing tricks and collect references to analyze and study. Not everyone wants—or is able—to invest thousands of hours into professional art studies. Drawing can simply be a recreational activity. But you still need a solid foundation to draw in the manga style, and an understanding of how to render realistic drawings. If you want to draw your fantasy characters or a character from a pen-and-paper role-playing game, I'd be happy to accompany you on your journey. This book is also for those who want to learn more about different manga styles and provides a great foundation on which you can build.

In this book, we'll use many references and examples you can use for practice. I'll share them with you to explain how to draw in a particular style and how you can make the most of your own references.

WHAT DO YOU NEED?

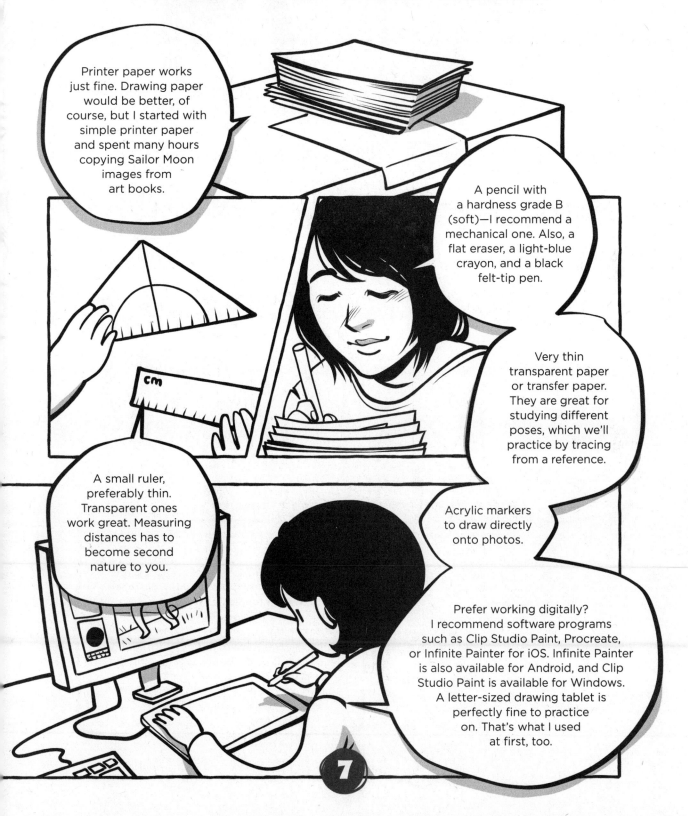

Printer paper works just fine. Drawing paper would be better, of course, but I started with simple printer paper and spent many hours copying Sailor Moon images from art books.

A pencil with a hardness grade B (soft)—I recommend a mechanical one. Also, a flat eraser, a light-blue crayon, and a black felt-tip pen.

Very thin transparent paper or transfer paper. They are great for studying different poses, which we'll practice by tracing from a reference.

A small ruler, preferably thin. Transparent ones work great. Measuring distances has to become second nature to you.

Acrylic markers to draw directly onto photos.

Prefer working digitally? I recommend software programs such as Clip Studio Paint, Procreate, or Infinite Painter for iOS. Infinite Painter is also available for Android, and Clip Studio Paint is available for Windows. A letter-sized drawing tablet is perfectly fine to practice on. That's what I used at first, too.

WARM-UP EXERCISES

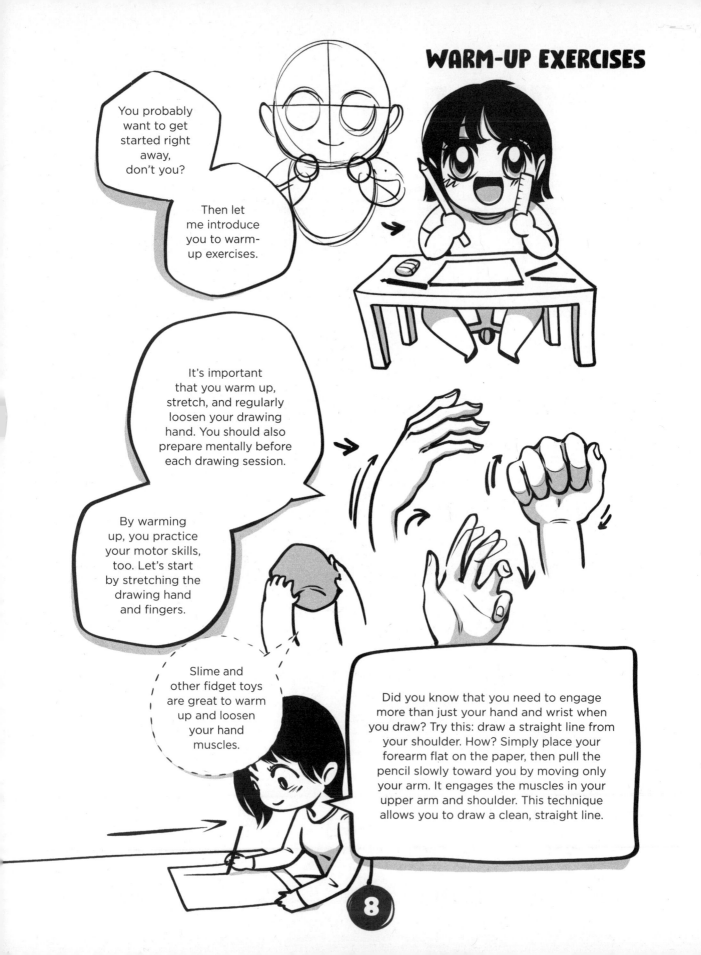

MOTOR SKILLS EXERCISES

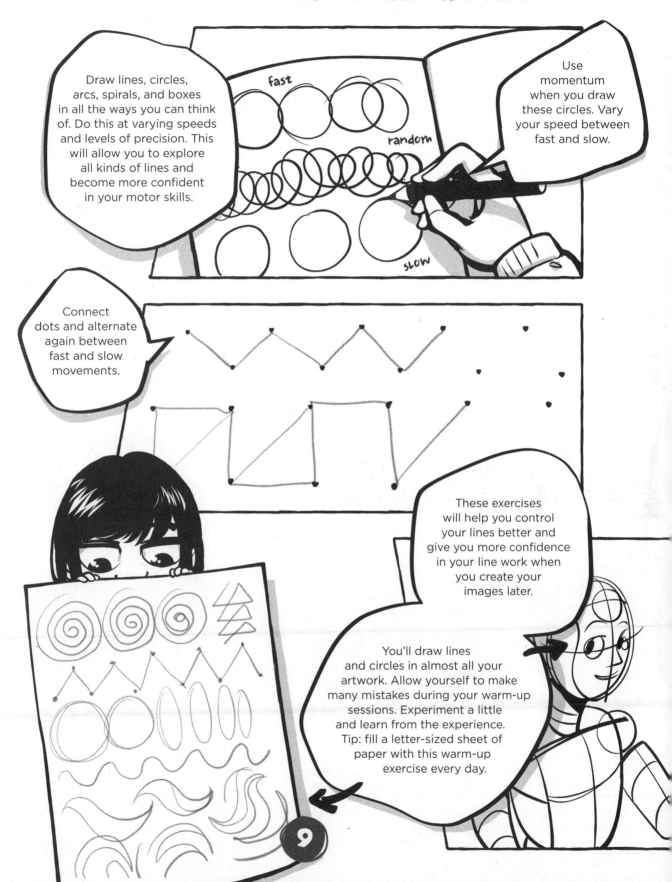

Draw lines, circles, arcs, spirals, and boxes in all the ways you can think of. Do this at varying speeds and levels of precision. This will allow you to explore all kinds of lines and become more confident in your motor skills.

Use momentum when you draw these circles. Vary your speed between fast and slow.

Connect dots and alternate again between fast and slow movements.

These exercises will help you control your lines better and give you more confidence in your line work when you create your images later.

You'll draw lines and circles in almost all your artwork. Allow yourself to make many mistakes during your warm-up sessions. Experiment a little and learn from the experience. Tip: fill a letter-sized sheet of paper with this warm-up exercise every day.

9

FORM STUDIES

When we look down at this object, we just see a circle, but from the side, it is a cylinder.

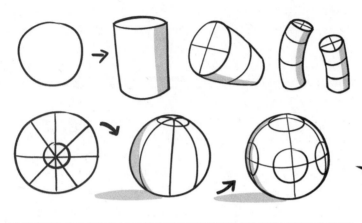

Perspective is a topic that could fill an entire book, but fortunately you'll only need some basic knowledge to work with my drawings. I want to show you how to break down complicated human bodies into more easily identifiable shapes. I'll touch on perspective but won't go into too much detail.

It will take time for you to understand the human head and its many planes, but you'll get there over time with practice.

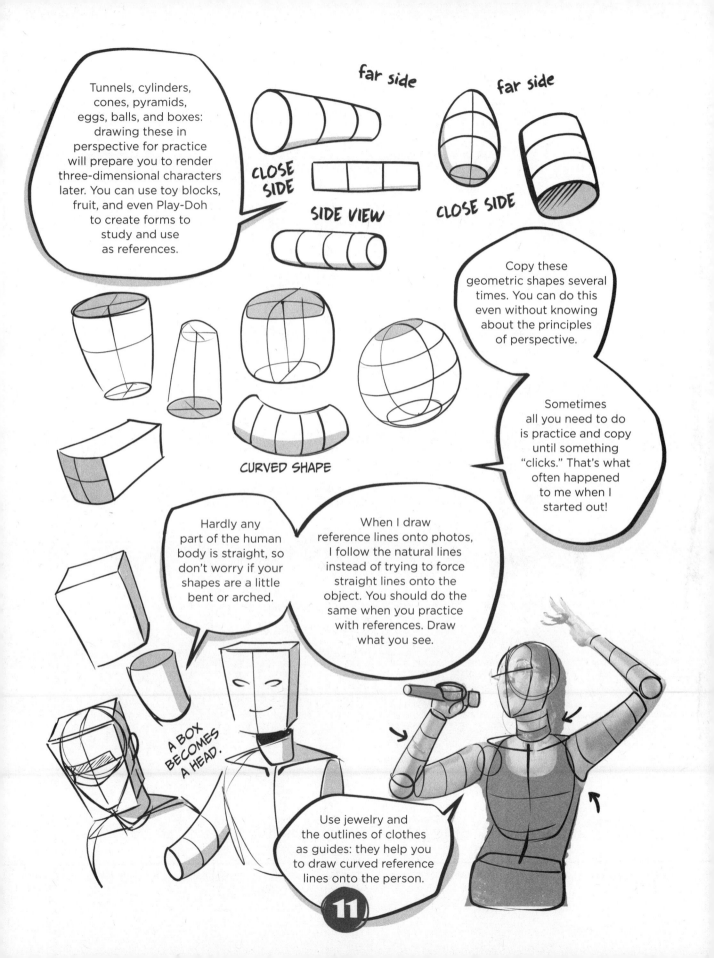

Tunnels, cylinders, cones, pyramids, eggs, balls, and boxes: drawing these in perspective for practice will prepare you to render three-dimensional characters later. You can use toy blocks, fruit, and even Play-Doh to create forms to study and use as references.

far side

far side

CLOSE SIDE

SIDE VIEW

CLOSE SIDE

CURVED SHAPE

Copy these geometric shapes several times. You can do this even without knowing about the principles of perspective.

Sometimes all you need to do is practice and copy until something "clicks." That's what often happened to me when I started out!

Hardly any part of the human body is straight, so don't worry if your shapes are a little bent or arched.

When I draw reference lines onto photos, I follow the natural lines instead of trying to force straight lines onto the object. You should do the same when you practice with references. Draw what you see.

A BOX BECOMES A HEAD.

Use jewelry and the outlines of clothes as guides: they help you to draw curved reference lines onto the person.

11

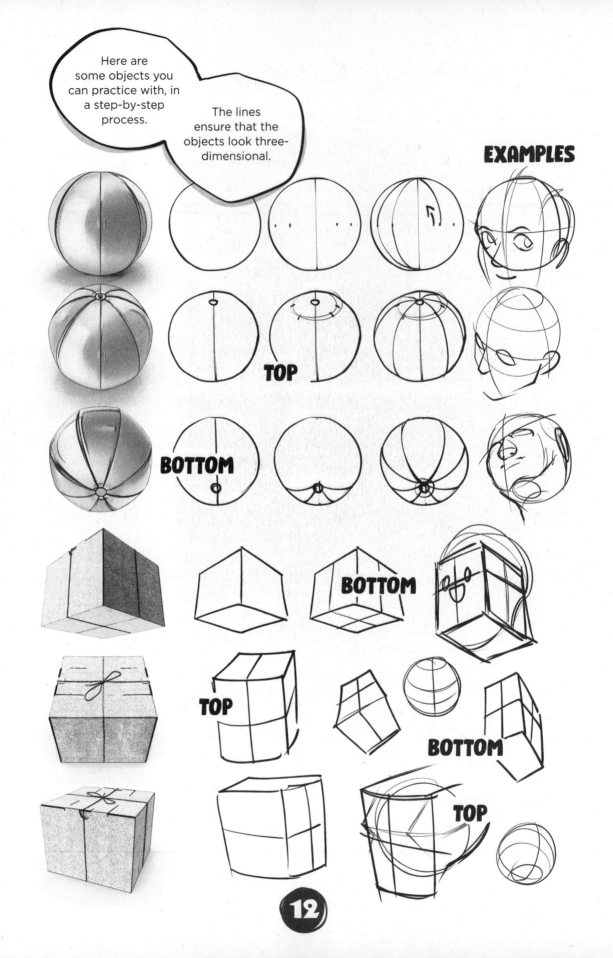

Here are some objects you can practice with, in a step-by-step process.

The lines ensure that the objects look three-dimensional.

EXAMPLES

TOP

BOTTOM

BOTTOM

TOP

BOTTOM

TOP

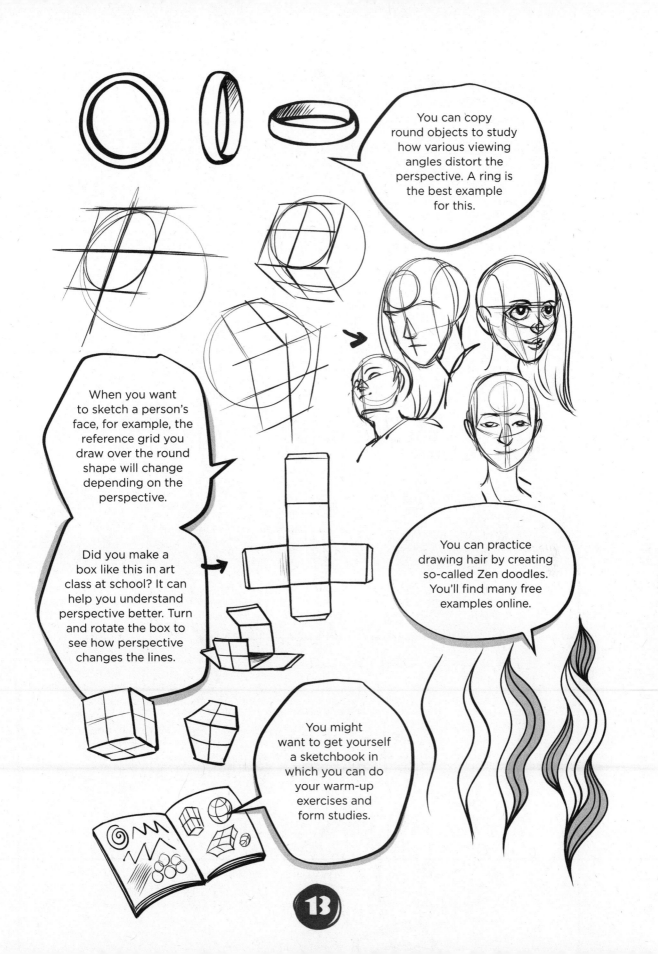

You can copy round objects to study how various viewing angles distort the perspective. A ring is the best example for this.

When you want to sketch a person's face, for example, the reference grid you draw over the round shape will change depending on the perspective.

Did you make a box like this in art class at school? It can help you understand perspective better. Turn and rotate the box to see how perspective changes the lines.

You can practice drawing hair by creating so-called Zen doodles. You'll find many free examples online.

You might want to get yourself a sketchbook in which you can do your warm-up exercises and form studies.

THE BASICS

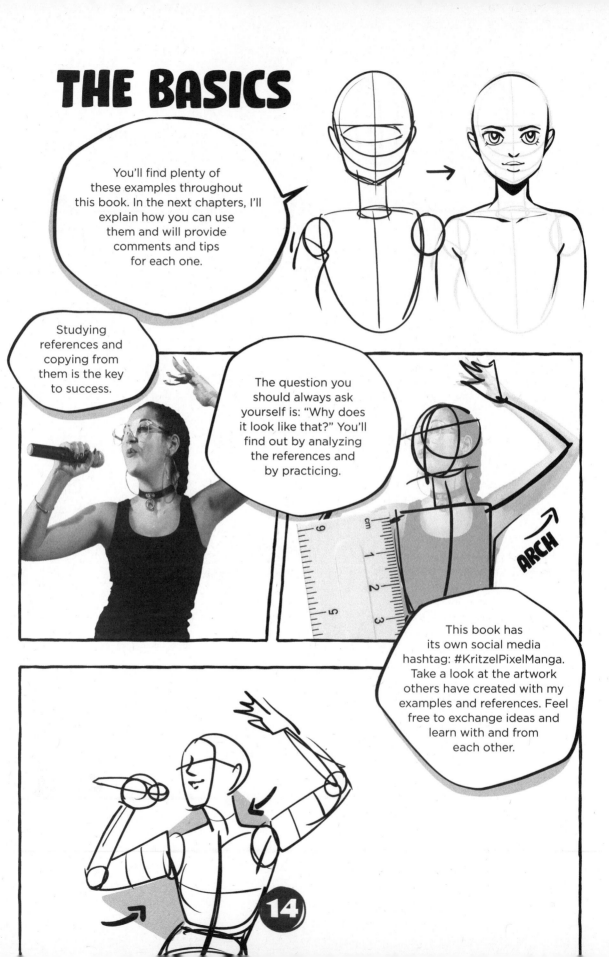

You'll find plenty of these examples throughout this book. In the next chapters, I'll explain how you can use them and will provide comments and tips for each one.

Studying references and copying from them is the key to success.

The question you should always ask yourself is: "Why does it look like that?" You'll find out by analyzing the references and by practicing.

This book has its own social media hashtag: #KritzelPixelManga. Take a look at the artwork others have created with my examples and references. Feel free to exchange ideas and learn with and from each other.

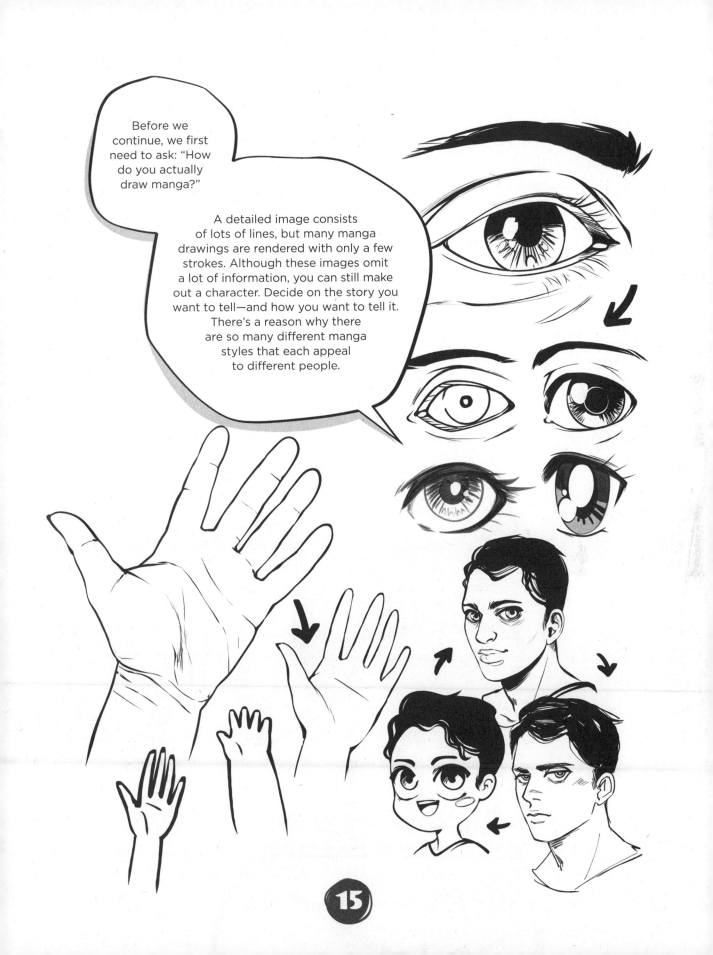

Before we continue, we first need to ask: "How do you actually draw manga?"

A detailed image consists of lots of lines, but many manga drawings are rendered with only a few strokes. Although these images omit a lot of information, you can still make out a character. Decide on the story you want to tell—and how you want to tell it. There's a reason why there are so many different manga styles that each appeal to different people.

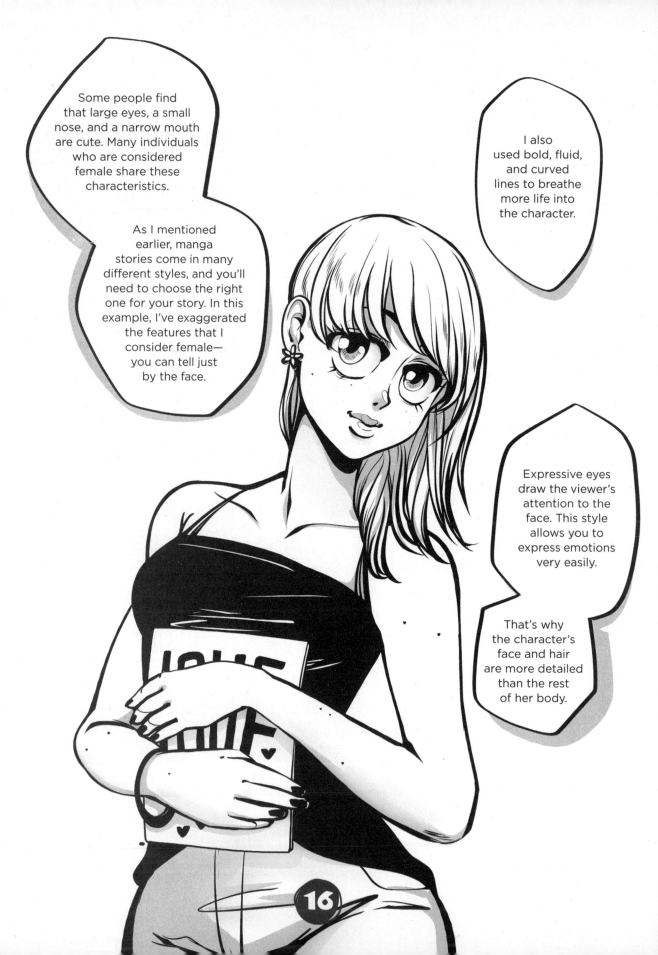

Some people find that large eyes, a small nose, and a narrow mouth are cute. Many individuals who are considered female share these characteristics.

As I mentioned earlier, manga stories come in many different styles, and you'll need to choose the right one for your story. In this example, I've exaggerated the features that I consider female— you can tell just by the face.

I also used bold, fluid, and curved lines to breathe more life into the character.

Expressive eyes draw the viewer's attention to the face. This style allows you to express emotions very easily.

That's why the character's face and hair are more detailed than the rest of her body.

16

I already mentioned that manga stories can be full of vibrant characters and exciting scenes. Get inspired by the comics that speak to you and decide which style you want to adopt for your drawings.

Personally, I always use the style that best fits the story I want to tell.

STYLES

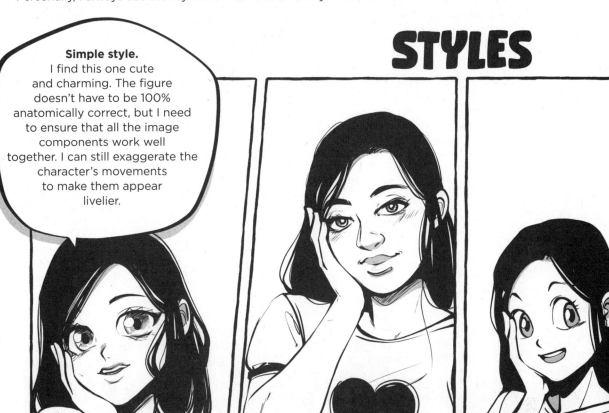

Simple style.
I find this one cute and charming. The figure doesn't have to be 100% anatomically correct, but I need to ensure that all the image components work well together. I can still exaggerate the character's movements to make them appear livelier.

Realistic style.
Here I have a much more mature plot in mind. This style allows me to add many details, both to the character and to the background. Also, the emotions appear more authentic and real.

Bold style.
Stronger and thicker lines. You often see this style in action manga. Sharp edges work well for fight scenes, for example.

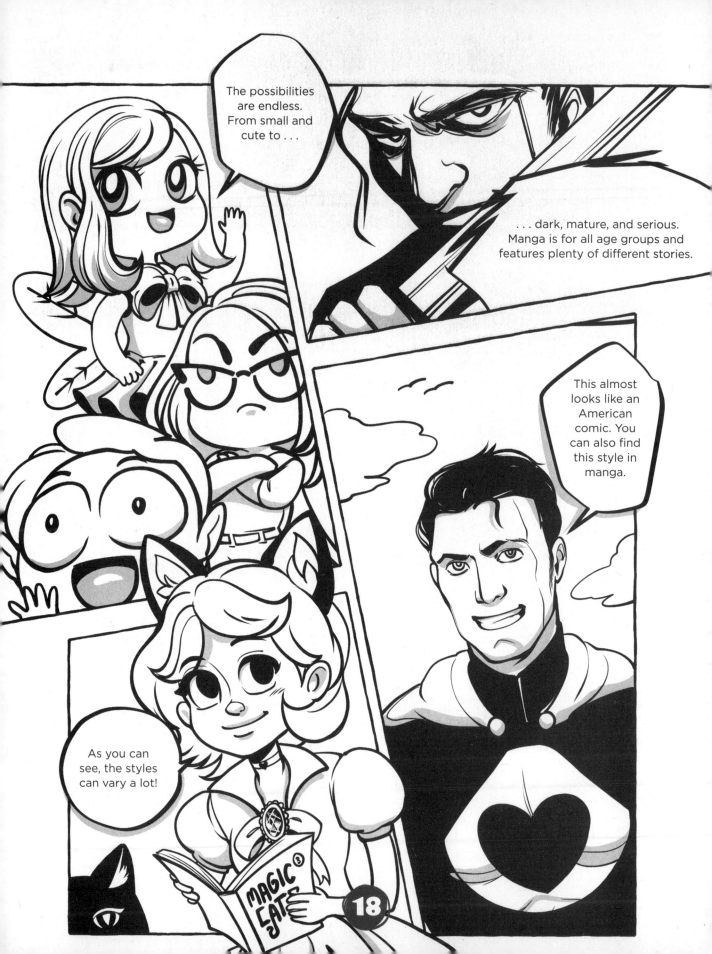

CHAPTER 2
HOW TO DRAW FACES

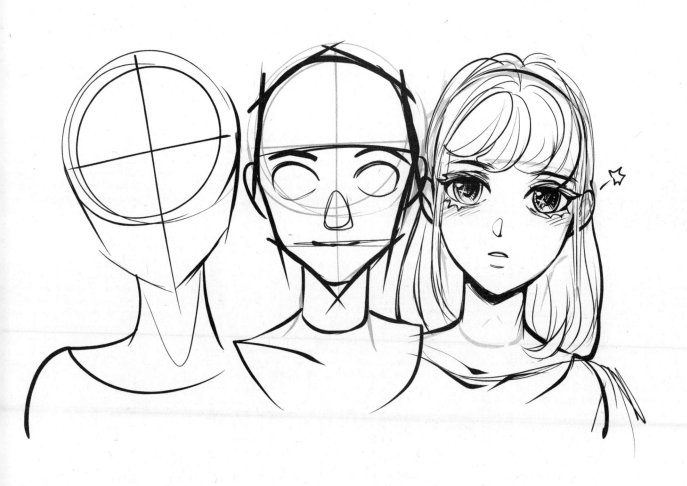

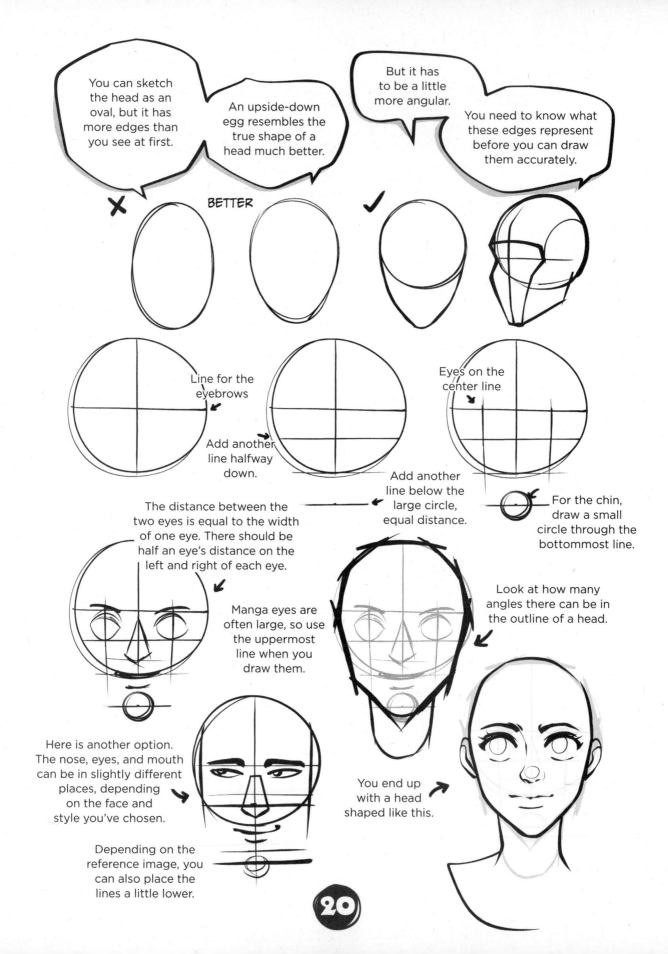

You can sketch the head as an oval, but it has more edges than you see at first.

An upside-down egg resembles the true shape of a head much better.

But it has to be a little more angular.

You need to know what these edges represent before you can draw them accurately.

X BETTER ✓

Line for the eyebrows

Add another line halfway down.

Eyes on the center line

Add another line below the large circle, equal distance.

For the chin, draw a small circle through the bottommost line.

The distance between the two eyes is equal to the width of one eye. There should be half an eye's distance on the left and right of each eye.

Manga eyes are often large, so use the uppermost line when you draw them.

Look at how many angles there can be in the outline of a head.

Here is another option. The nose, eyes, and mouth can be in slightly different places, depending on the face and style you've chosen.

Depending on the reference image, you can also place the lines a little lower.

You end up with a head shaped like this.

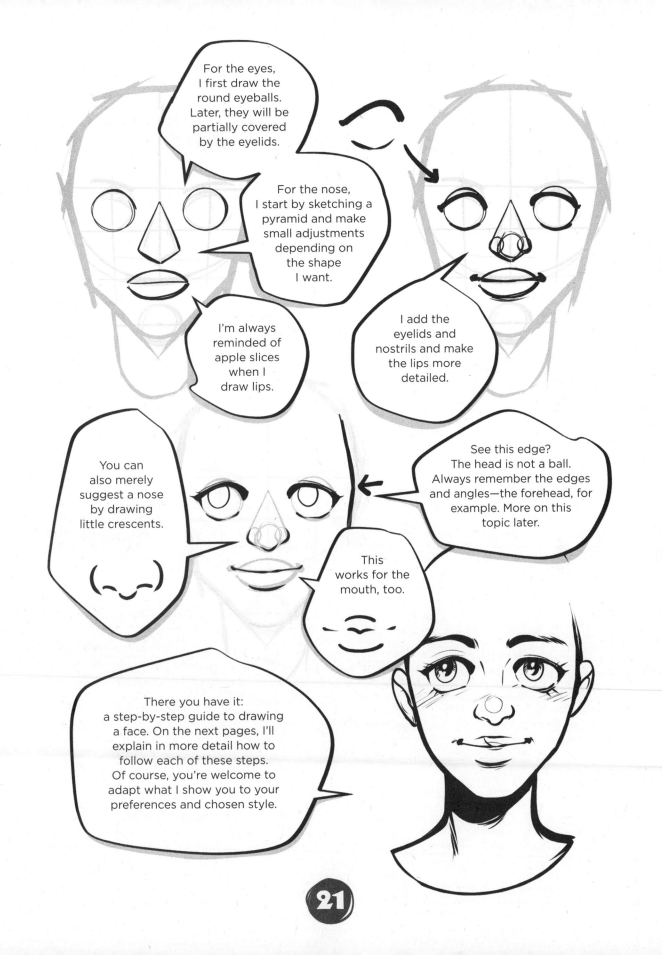

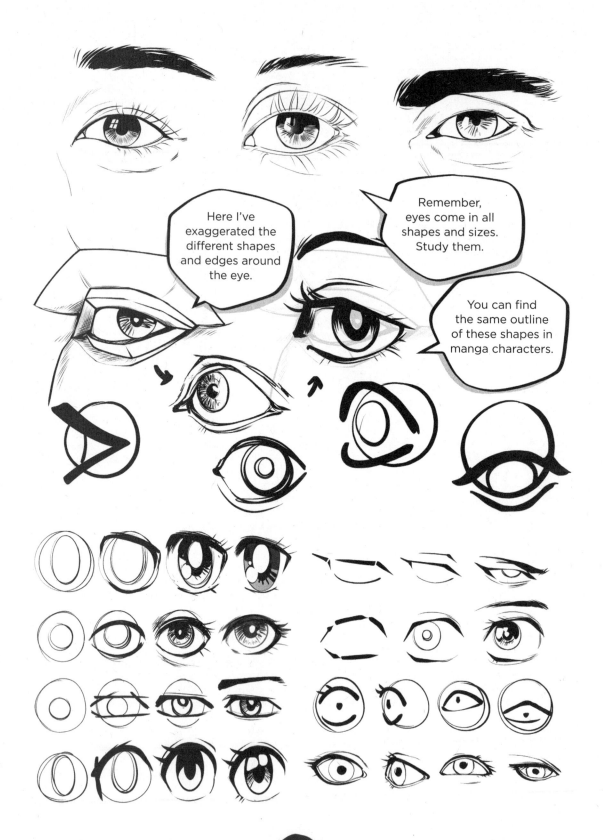

Here I've exaggerated the different shapes and edges around the eye.

Remember, eyes come in all shapes and sizes. Study them.

You can find the same outline of these shapes in manga characters.

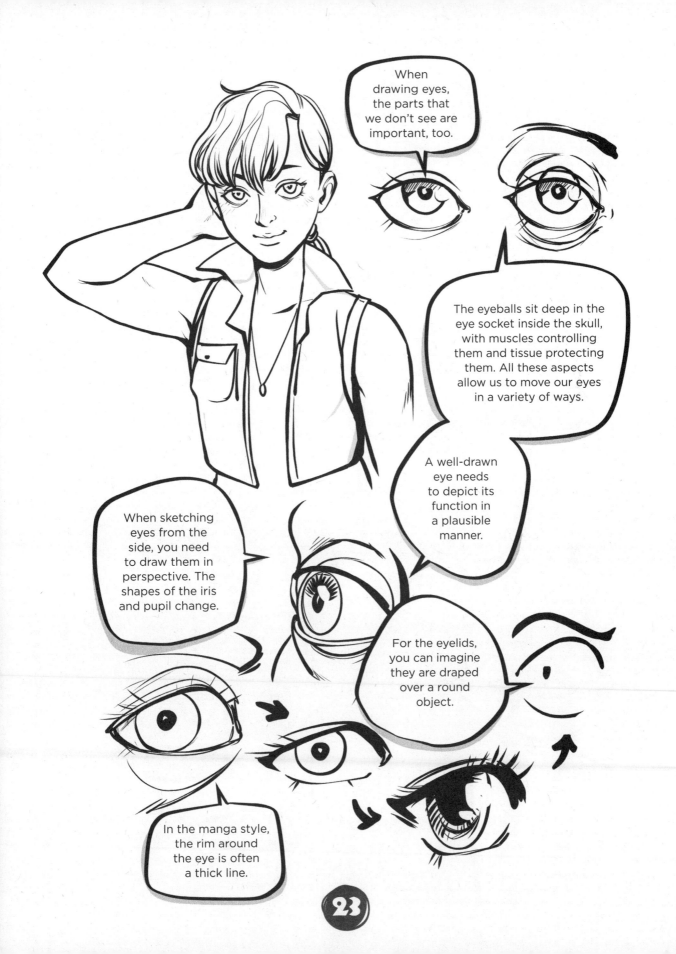

When drawing eyes, the parts that we don't see are important, too.

The eyeballs sit deep in the eye socket inside the skull, with muscles controlling them and tissue protecting them. All these aspects allow us to move our eyes in a variety of ways.

A well-drawn eye needs to depict its function in a plausible manner.

When sketching eyes from the side, you need to draw them in perspective. The shapes of the iris and pupil change.

For the eyelids, you can imagine they are draped over a round object.

In the manga style, the rim around the eye is often a thick line.

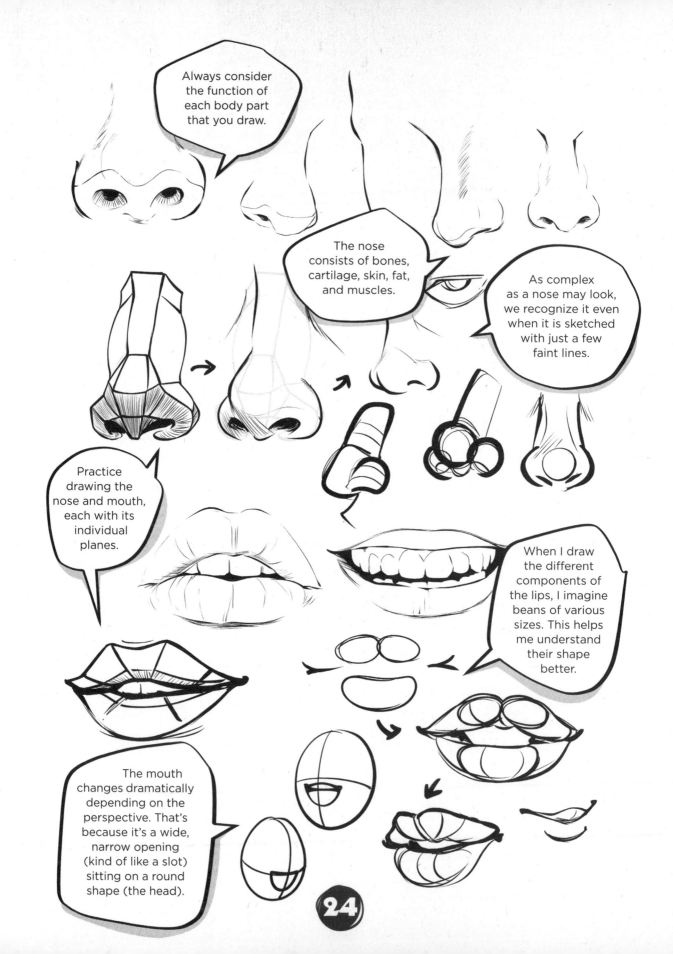

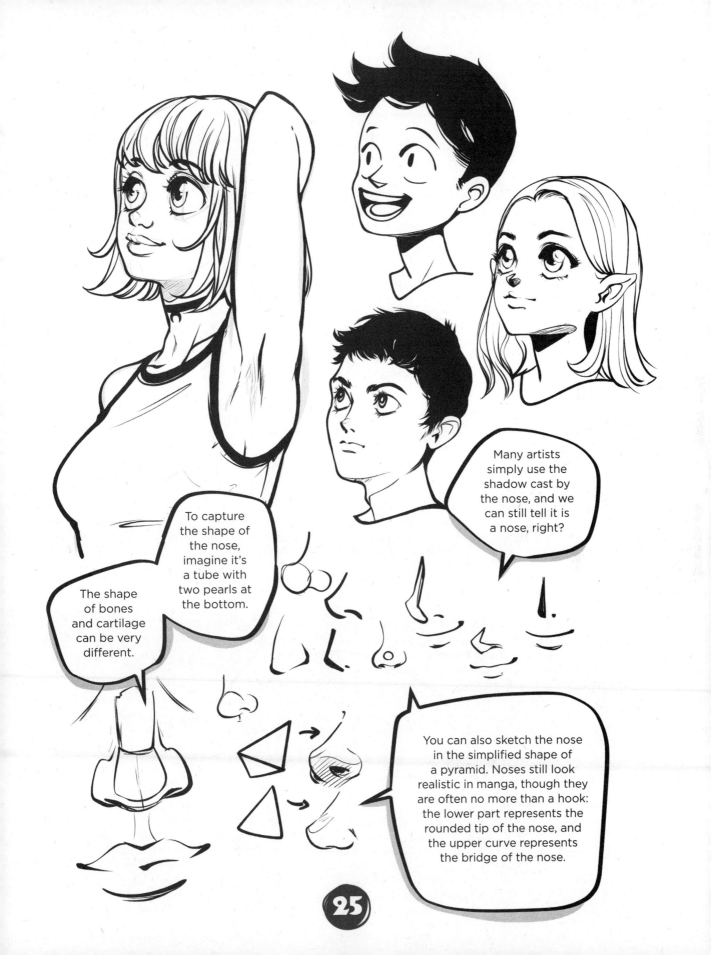

To capture the shape of the nose, imagine it's a tube with two pearls at the bottom.

The shape of bones and cartilage can be very different.

Many artists simply use the shadow cast by the nose, and we can still tell it is a nose, right?

You can also sketch the nose in the simplified shape of a pyramid. Noses still look realistic in manga, though they are often no more than a hook: the lower part represents the rounded tip of the nose, and the upper curve represents the bridge of the nose.

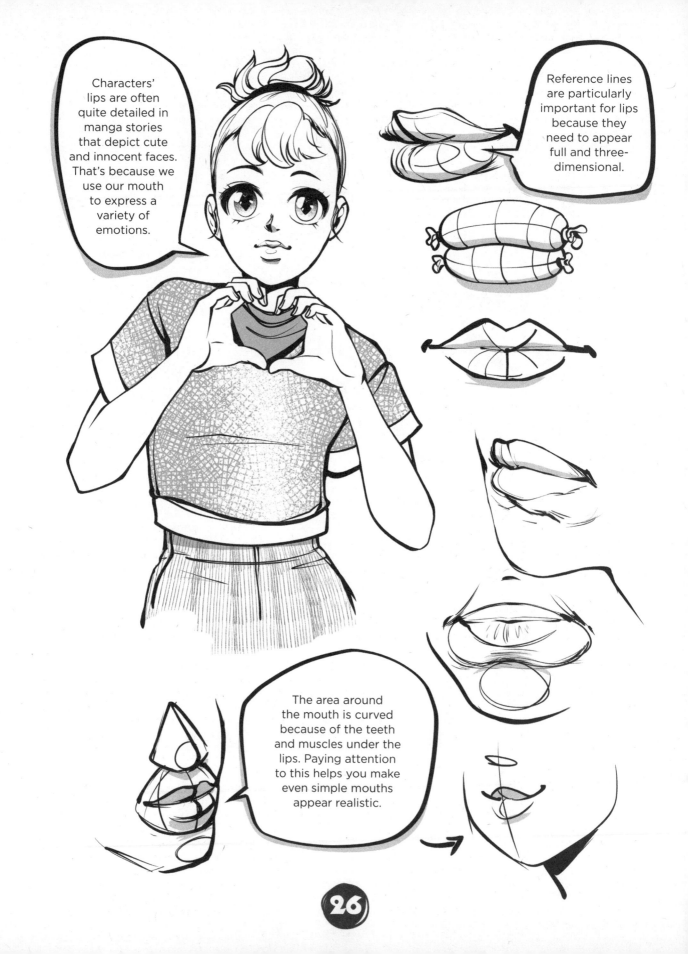

Characters' lips are often quite detailed in manga stories that depict cute and innocent faces. That's because we use our mouth to express a variety of emotions.

Reference lines are particularly important for lips because they need to appear full and three-dimensional.

The area around the mouth is curved because of the teeth and muscles under the lips. Paying attention to this helps you make even simple mouths appear realistic.

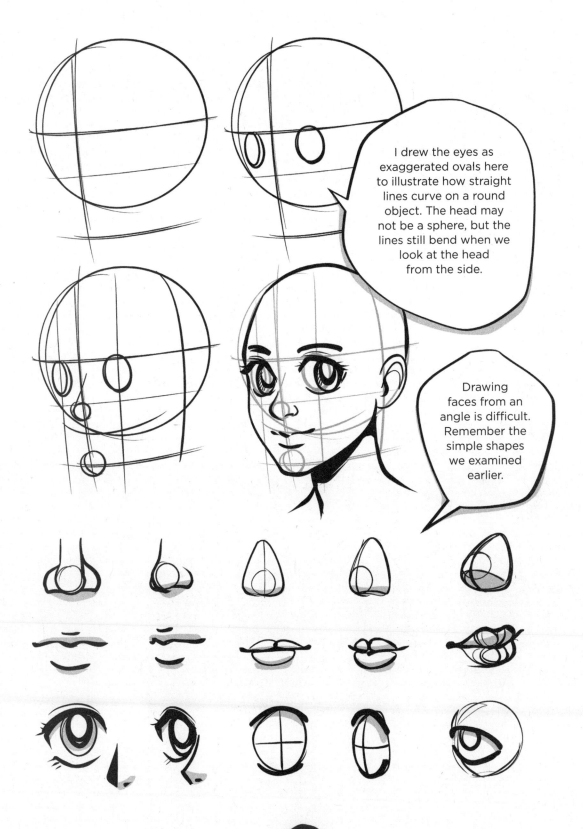

I drew the eyes as exaggerated ovals here to illustrate how straight lines curve on a round object. The head may not be a sphere, but the lines still bend when we look at the head from the side.

Drawing faces from an angle is difficult. Remember the simple shapes we examined earlier.

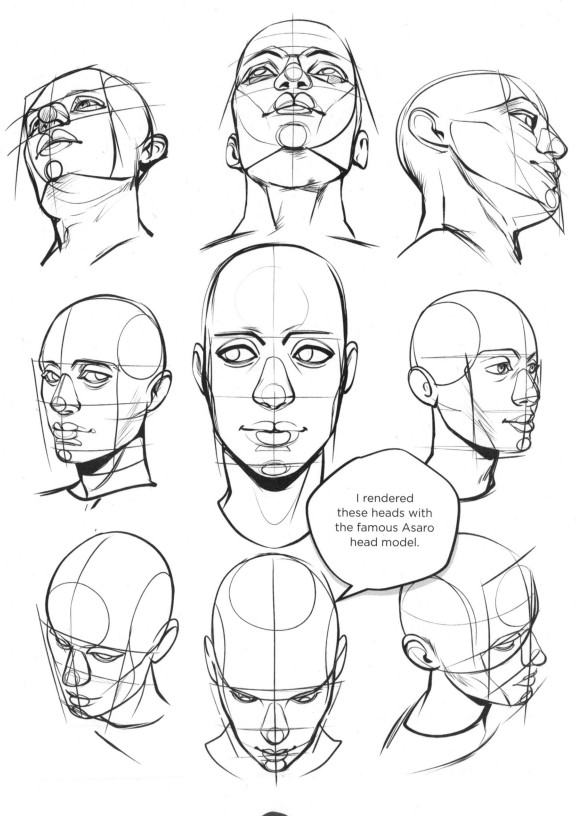

I rendered these heads with the famous Asaro head model.

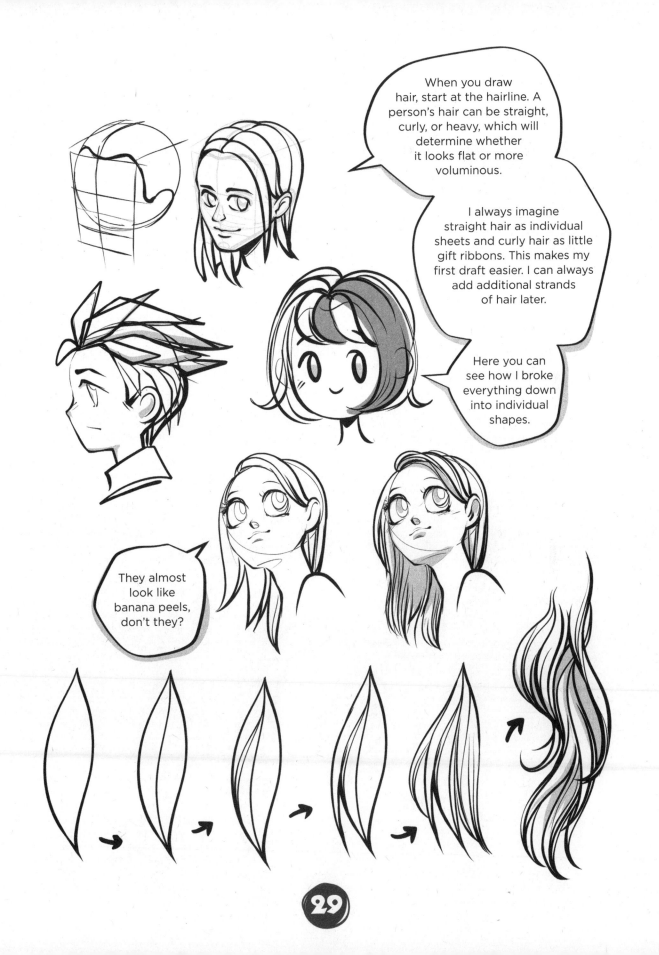

When you draw hair, start at the hairline. A person's hair can be straight, curly, or heavy, which will determine whether it looks flat or more voluminous.

I always imagine straight hair as individual sheets and curly hair as little gift ribbons. This makes my first draft easier. I can always add additional strands of hair later.

Here you can see how I broke everything down into individual shapes.

They almost look like banana peels, don't they?

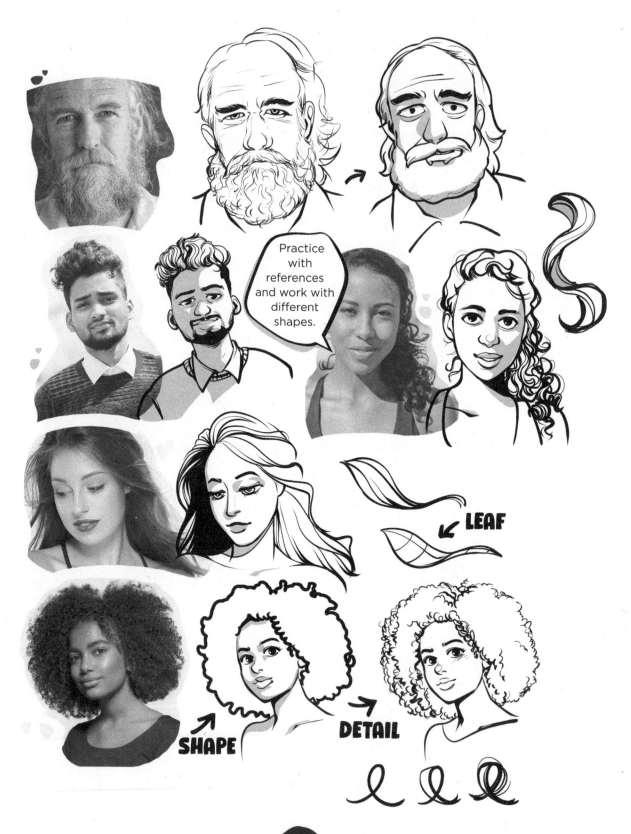

CHAPTER 3
HOW TO DRAW BODIES

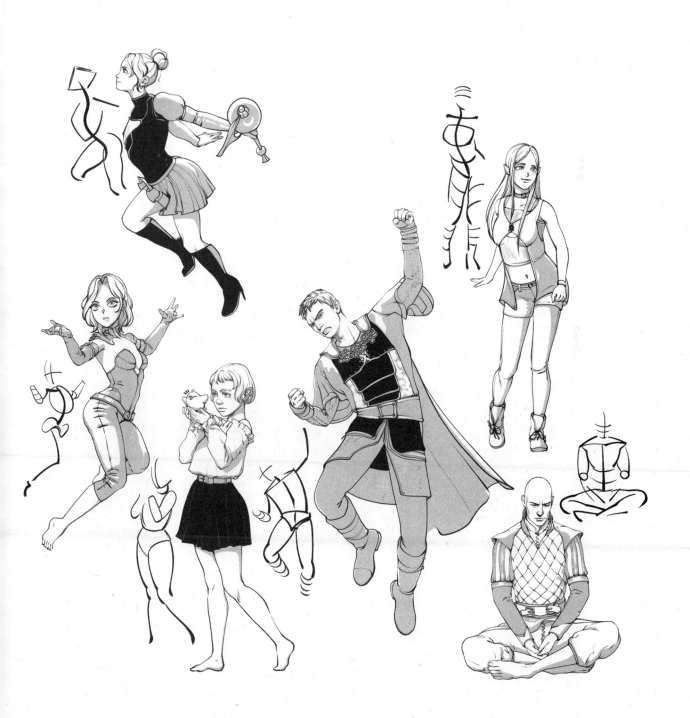

Now on to some general information on learning to draw.

Drawing requires a lot of knowledge and understanding. Trying to grasp everything at once is overwhelming. Instead, add to your existing knowledge base every time you practice.

You'll start by improving your fine motor skills, and discover how to draw fluid lines (page 9).

1.

When you practice your fine motor skills, also sketch a few poses using curved and straight lines.

Then you'll render full shapes. Look at references and draw their silhouettes. Focus only on each character's outline.

2.

Tip: you can already recognize interesting poses just based on the outline.

Pay attention to the areas behind and between each character's outline. This gray area is called the negative space, which usually consists of simple shapes that allow you to assess the spacing and distances correctly.

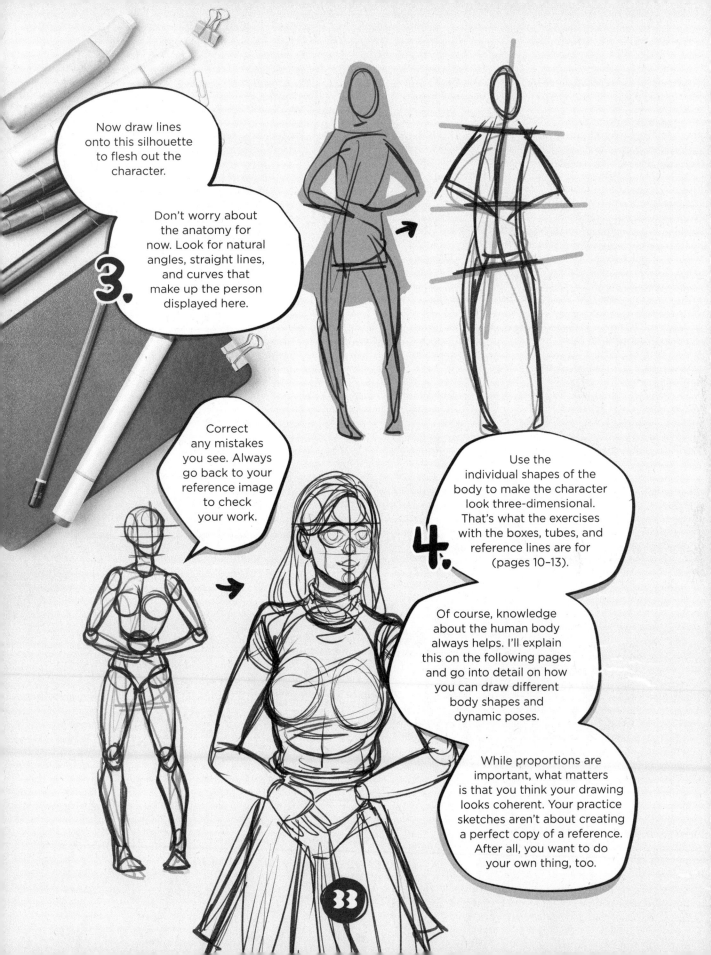

Now draw lines onto this silhouette to flesh out the character.

Don't worry about the anatomy for now. Look for natural angles, straight lines, and curves that make up the person displayed here.

3.

Correct any mistakes you see. Always go back to your reference image to check your work.

Use the individual shapes of the body to make the character look three-dimensional. That's what the exercises with the boxes, tubes, and reference lines are for (pages 10–13).

4.

Of course, knowledge about the human body always helps. I'll explain this on the following pages and go into detail on how you can draw different body shapes and dynamic poses.

While proportions are important, what matters is that you think your drawing looks coherent. Your practice sketches aren't about creating a perfect copy of a reference. After all, you want to do your own thing, too.

33

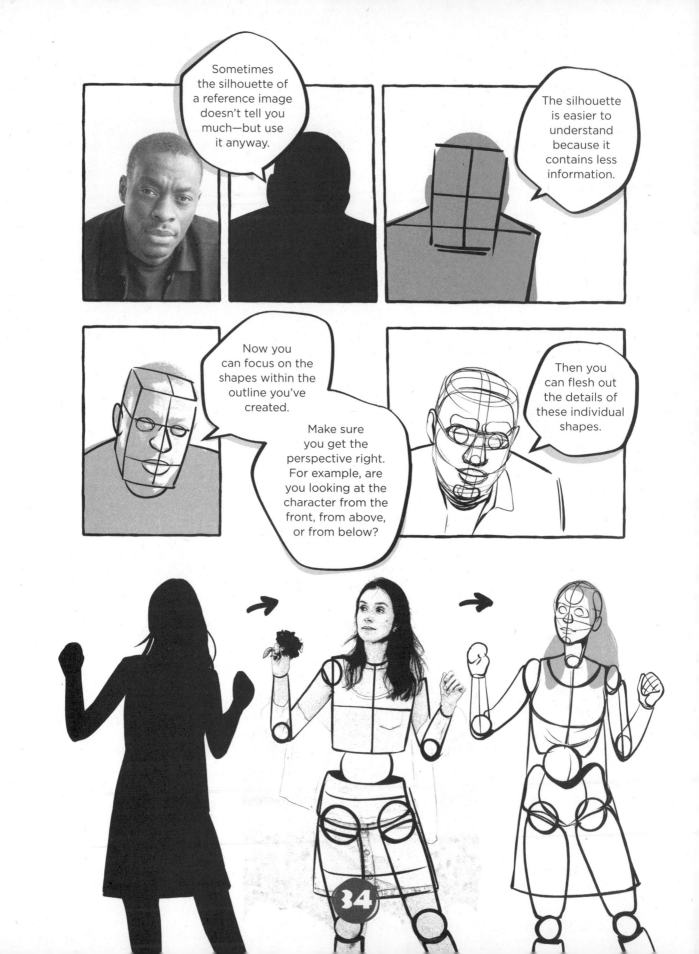

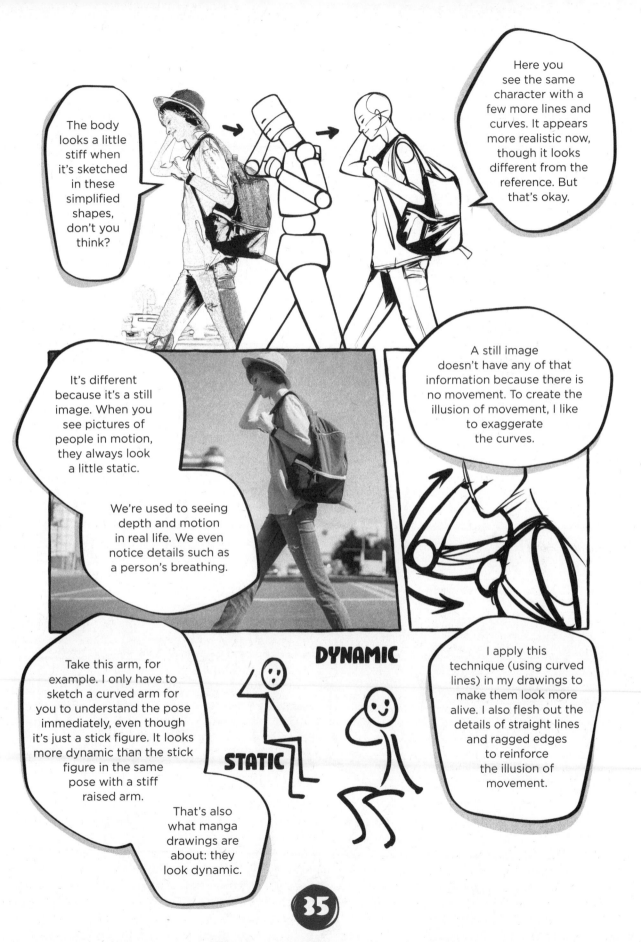

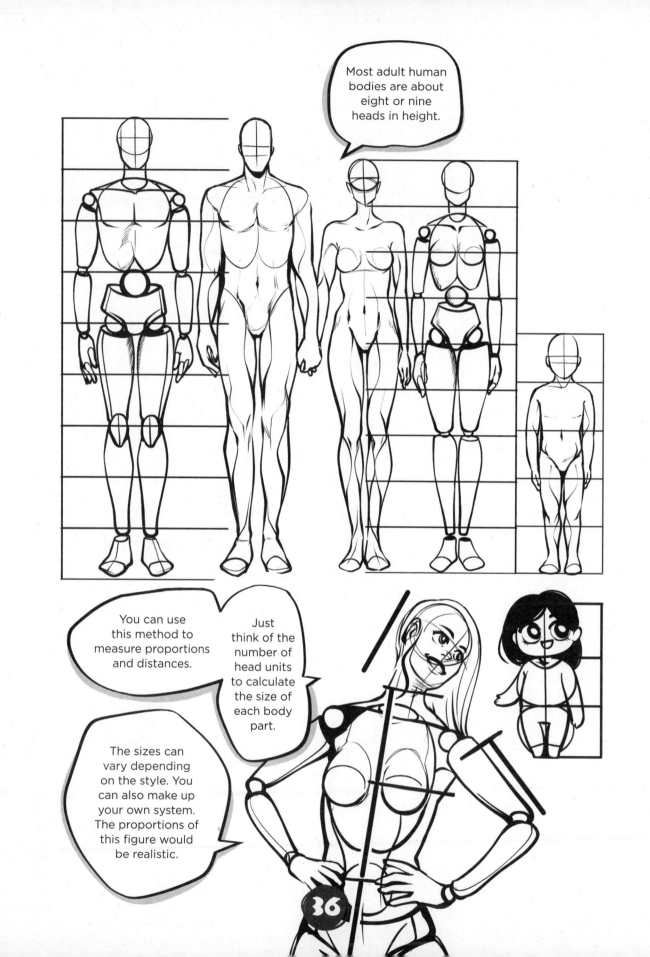

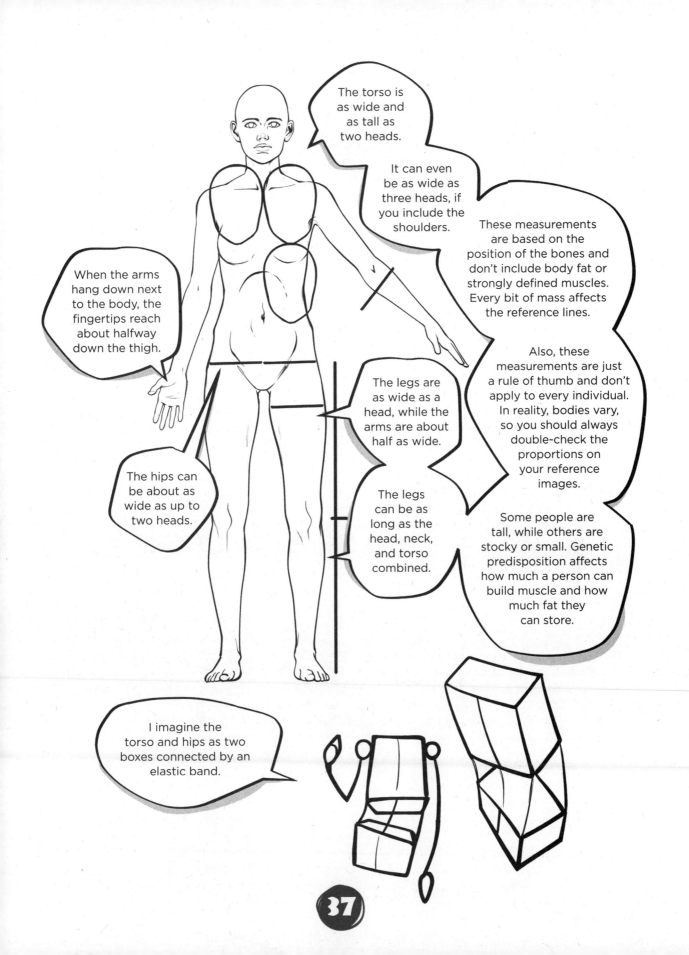

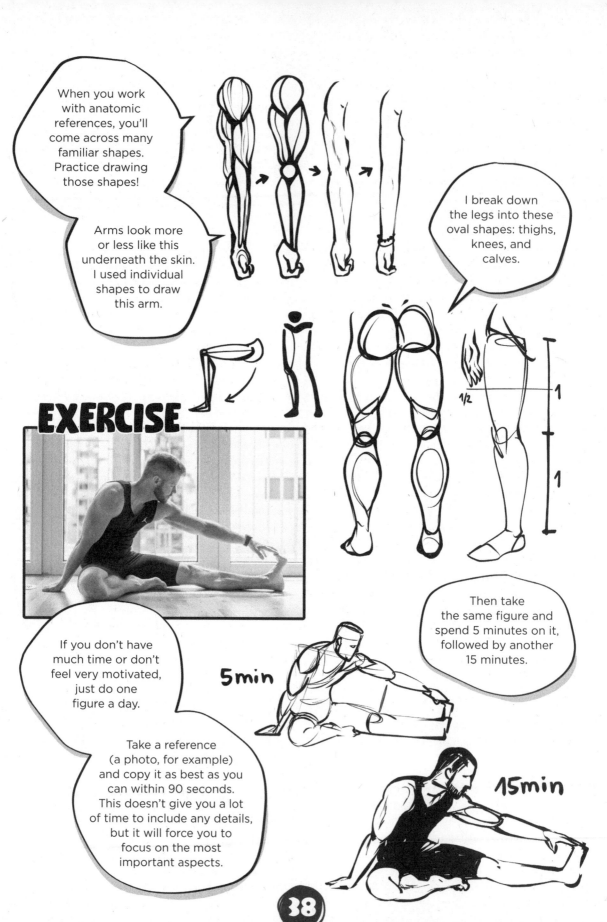

When you work with anatomic references, you'll come across many familiar shapes. Practice drawing those shapes!

Arms look more or less like this underneath the skin. I used individual shapes to draw this arm.

I break down the legs into these oval shapes: thighs, knees, and calves.

EXERCISE

If you don't have much time or don't feel very motivated, just do one figure a day.

Then take the same figure and spend 5 minutes on it, followed by another 15 minutes.

Take a reference (a photo, for example) and copy it as best as you can within 90 seconds. This doesn't give you a lot of time to include any details, but it will force you to focus on the most important aspects.

5min

15min

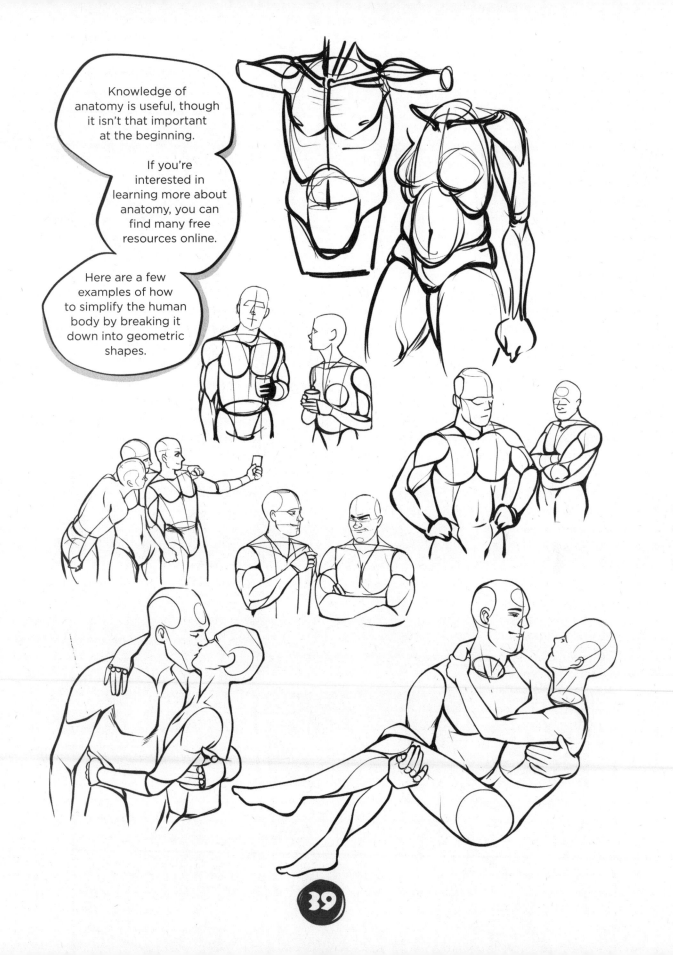

Knowledge of anatomy is useful, though it isn't that important at the beginning.

If you're interested in learning more about anatomy, you can find many free resources online.

Here are a few examples of how to simplify the human body by breaking it down into geometric shapes.

USING REFERENCE LINES

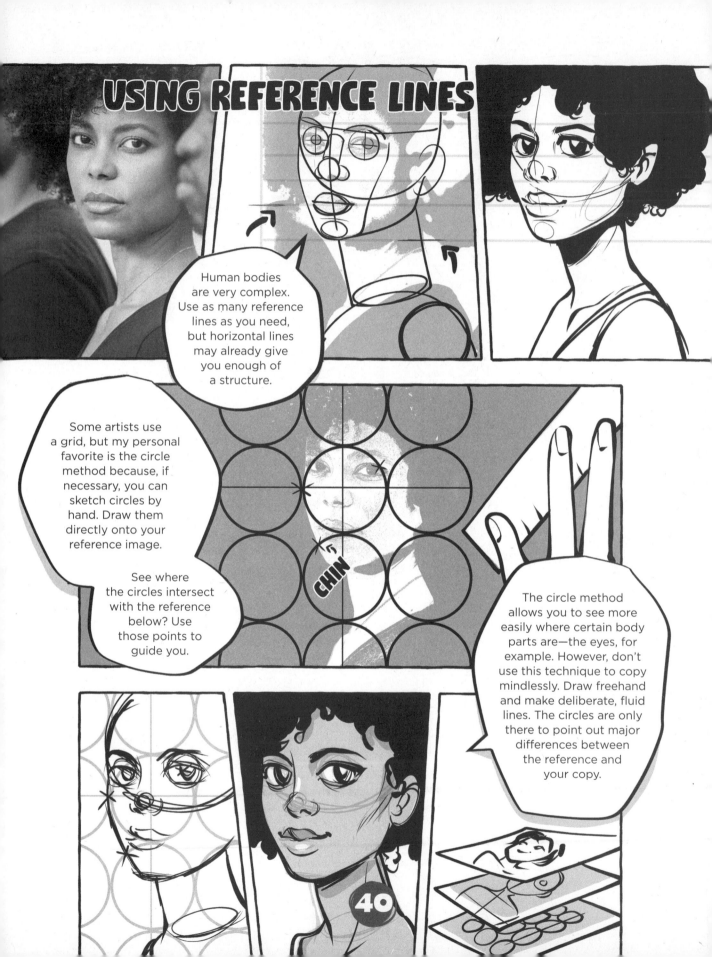

Human bodies are very complex. Use as many reference lines as you need, but horizontal lines may already give you enough of a structure.

Some artists use a grid, but my personal favorite is the circle method because, if necessary, you can sketch circles by hand. Draw them directly onto your reference image.

See where the circles intersect with the reference below? Use those points to guide you.

CHIN

The circle method allows you to see more easily where certain body parts are—the eyes, for example. However, don't use this technique to copy mindlessly. Draw freehand and make deliberate, fluid lines. The circles are only there to point out major differences between the reference and your copy.

Not all examples in this book include reference lines. After all, you'll need to learn to find references (photos, for example) to which you can add your own reference lines. Draw the individual shapes and follow the angles and straight lines of the body.

Take a thin sheet of paper and place it on top of your reference image.

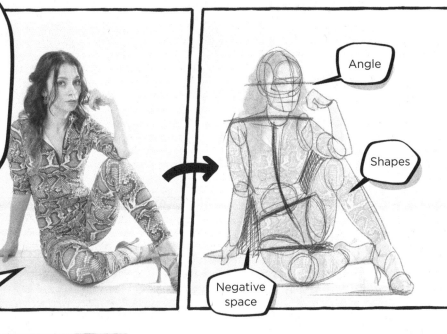

Angle

Shapes

Negative space

It's okay if your reference lines look a little chaotic.

If you want to create an image using the circle method (page 40), you can either draw the circles directly onto your sketching paper or onto an ultra-thin, transparent sheet of paper.

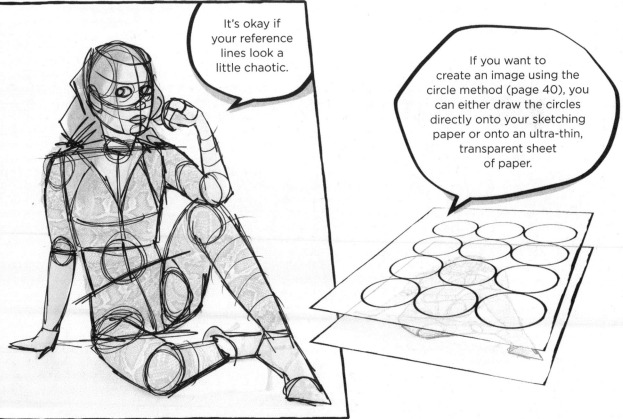

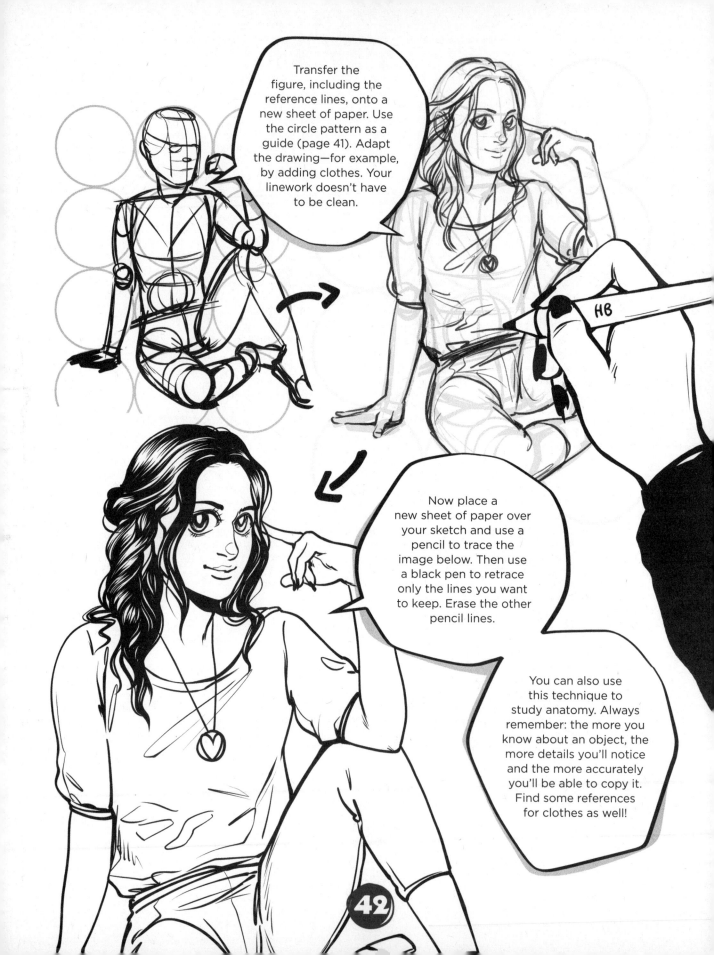

Transfer the figure, including the reference lines, onto a new sheet of paper. Use the circle pattern as a guide (page 41). Adapt the drawing—for example, by adding clothes. Your linework doesn't have to be clean.

Now place a new sheet of paper over your sketch and use a pencil to trace the image below. Then use a black pen to retrace only the lines you want to keep. Erase the other pencil lines.

You can also use this technique to study anatomy. Always remember: the more you know about an object, the more details you'll notice and the more accurately you'll be able to copy it. Find some references for clothes as well!

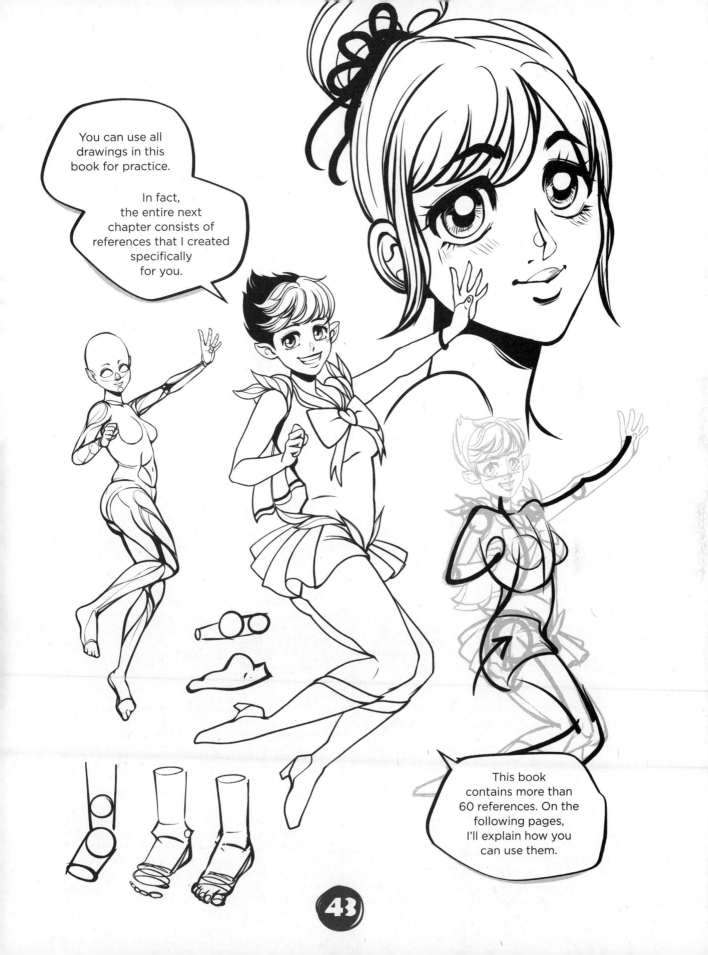

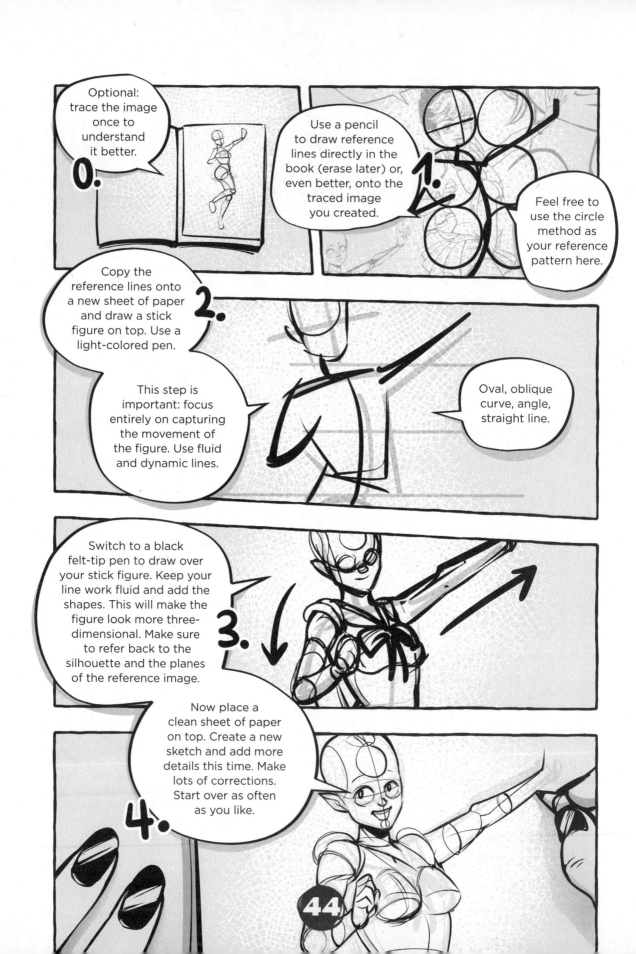

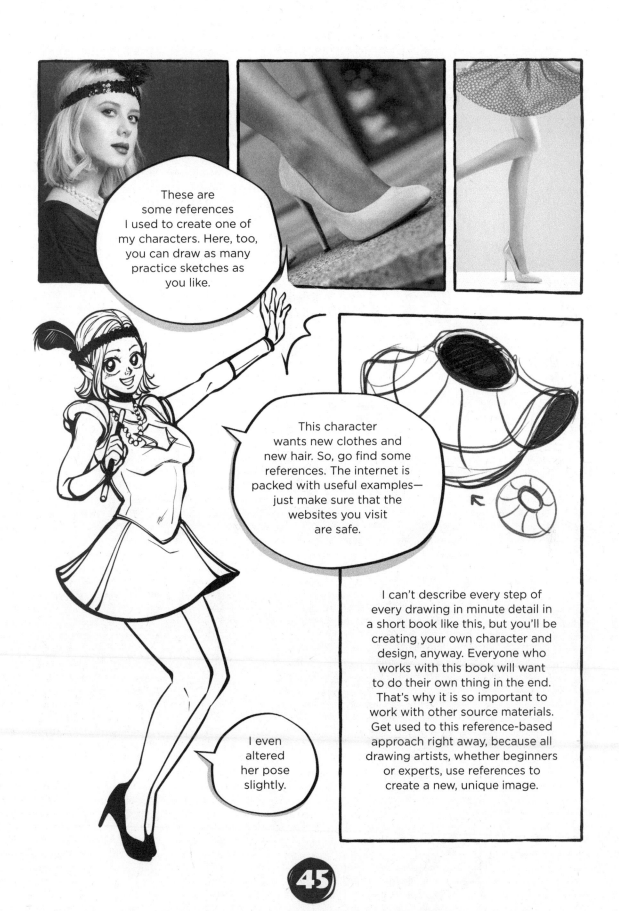

These are some references I used to create one of my characters. Here, too, you can draw as many practice sketches as you like.

This character wants new clothes and new hair. So, go find some references. The internet is packed with useful examples—just make sure that the websites you visit are safe.

I even altered her pose slightly.

I can't describe every step of every drawing in minute detail in a short book like this, but you'll be creating your own character and design, anyway. Everyone who works with this book will want to do their own thing in the end. That's why it is so important to work with other source materials. Get used to this reference-based approach right away, because all drawing artists, whether beginners or experts, use references to create a new, unique image.

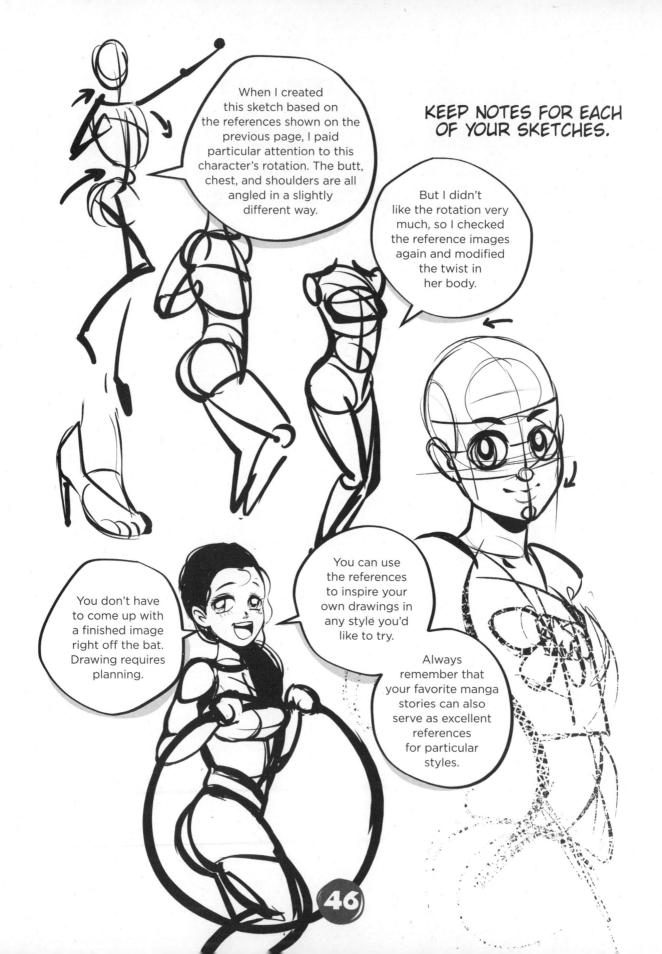

When I created this sketch based on the references shown on the previous page, I paid particular attention to this character's rotation. The butt, chest, and shoulders are all angled in a slightly different way.

KEEP NOTES FOR EACH OF YOUR SKETCHES.

But I didn't like the rotation very much, so I checked the reference images again and modified the twist in her body.

You don't have to come up with a finished image right off the bat. Drawing requires planning.

You can use the references to inspire your own drawings in any style you'd like to try.

Always remember that your favorite manga stories can also serve as excellent references for particular styles.

CHAPTER 4
HOW TO USE REFERENCES

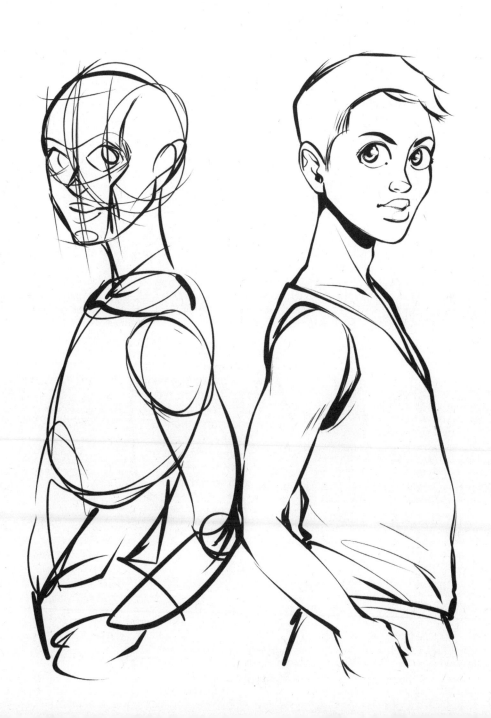

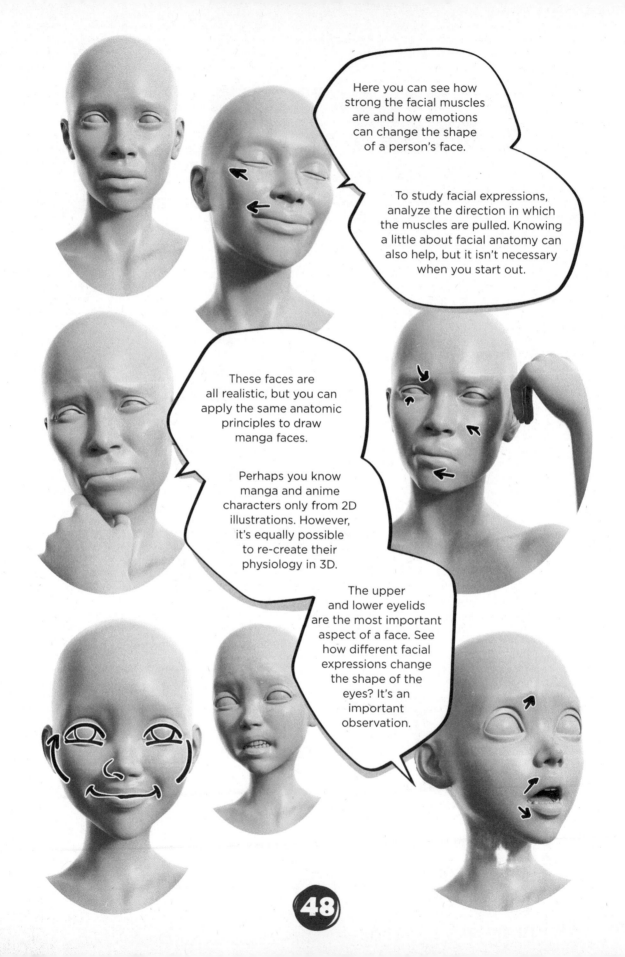

Here you can see how strong the facial muscles are and how emotions can change the shape of a person's face.

To study facial expressions, analyze the direction in which the muscles are pulled. Knowing a little about facial anatomy can also help, but it isn't necessary when you start out.

These faces are all realistic, but you can apply the same anatomic principles to draw manga faces.

Perhaps you know manga and anime characters only from 2D illustrations. However, it's equally possible to re-create their physiology in 3D.

The upper and lower eyelids are the most important aspect of a face. See how different facial expressions change the shape of the eyes? It's an important observation.

48

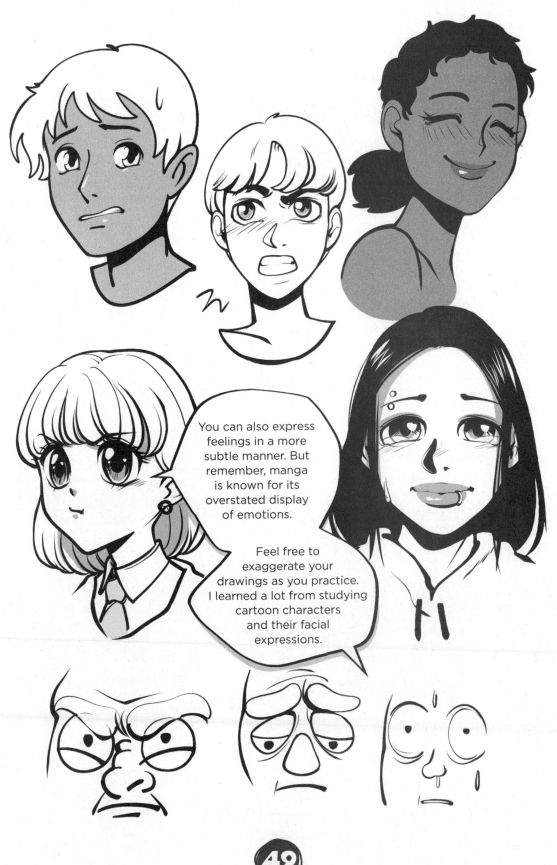

You can also express feelings in a more subtle manner. But remember, manga is known for its overstated display of emotions.

Feel free to exaggerate your drawings as you practice. I learned a lot from studying cartoon characters and their facial expressions.

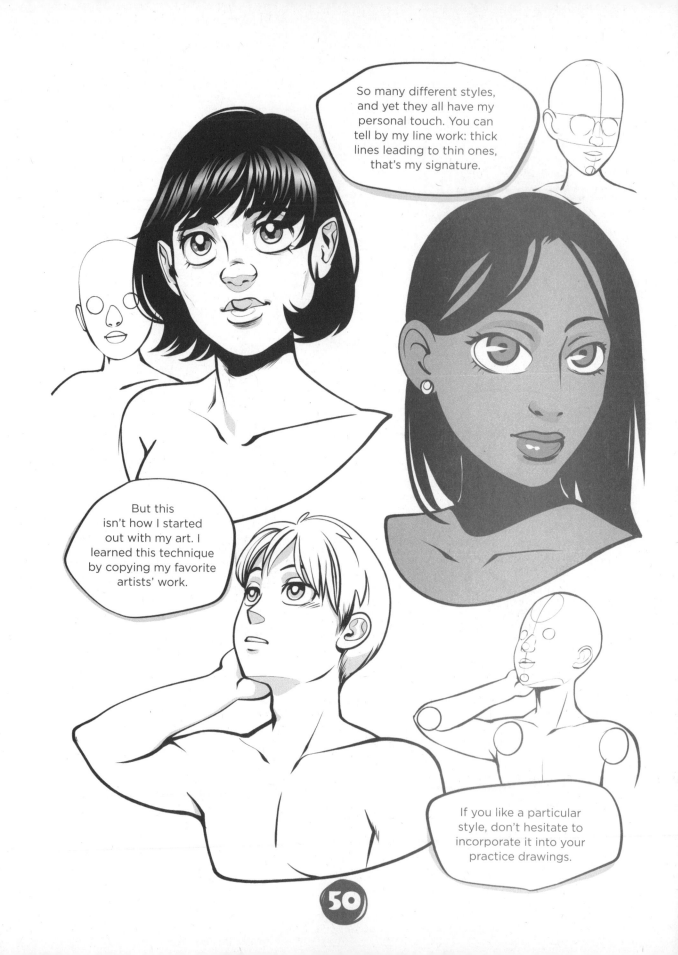

So many different styles, and yet they all have my personal touch. You can tell by my line work: thick lines leading to thin ones, that's my signature.

But this isn't how I started out with my art. I learned this technique by copying my favorite artists' work.

If you like a particular style, don't hesitate to incorporate it into your practice drawings.

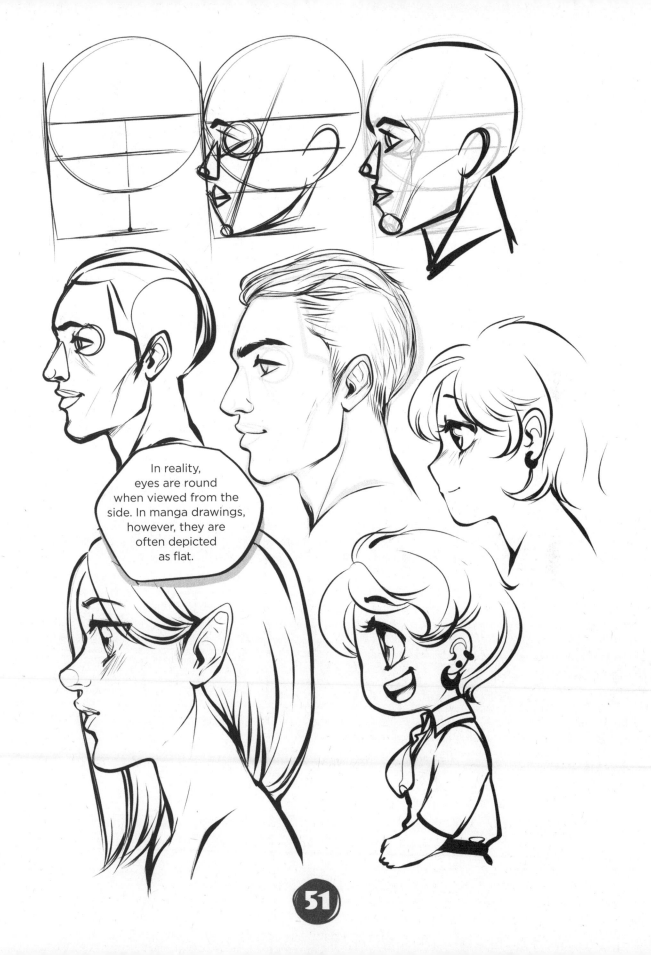

In reality, eyes are round when viewed from the side. In manga drawings, however, they are often depicted as flat.

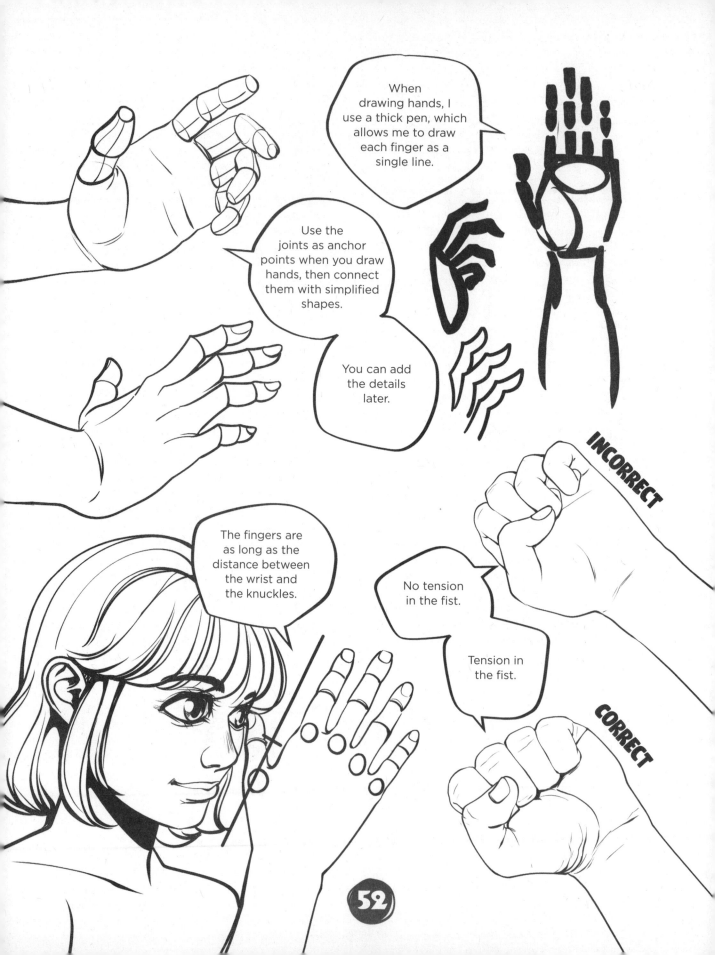

When drawing hands, I use a thick pen, which allows me to draw each finger as a single line.

Use the joints as anchor points when you draw hands, then connect them with simplified shapes.

You can add the details later.

The fingers are as long as the distance between the wrist and the knuckles.

No tension in the fist.

Tension in the fist.

INCORRECT

CORRECT

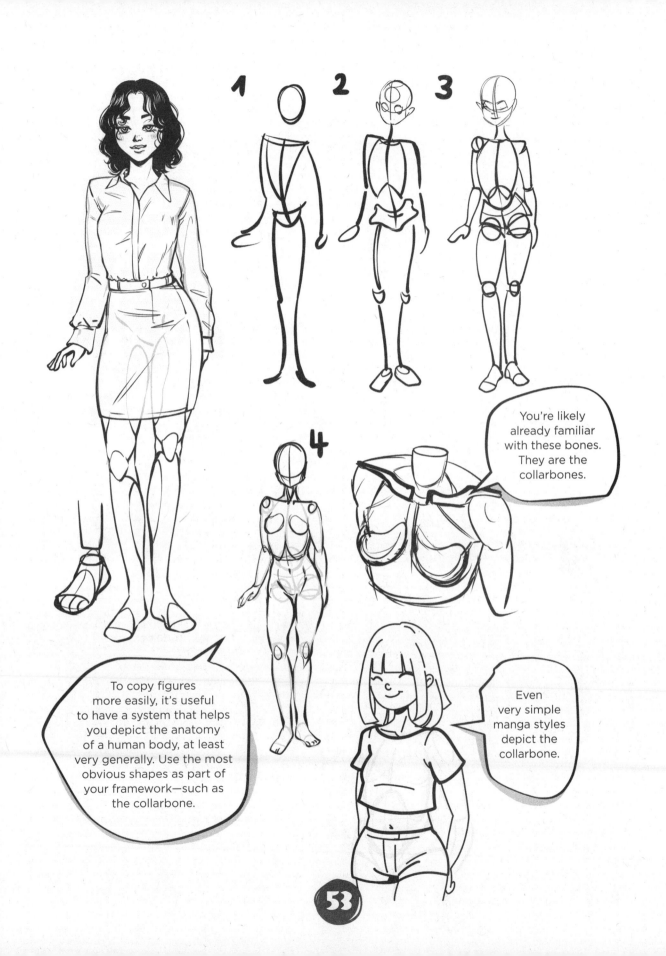

1 **2** **3**

4

You're likely already familiar with these bones. They are the collarbones.

To copy figures more easily, it's useful to have a system that helps you depict the anatomy of a human body, at least very generally. Use the most obvious shapes as part of your framework—such as the collarbone.

Even very simple manga styles depict the collarbone.

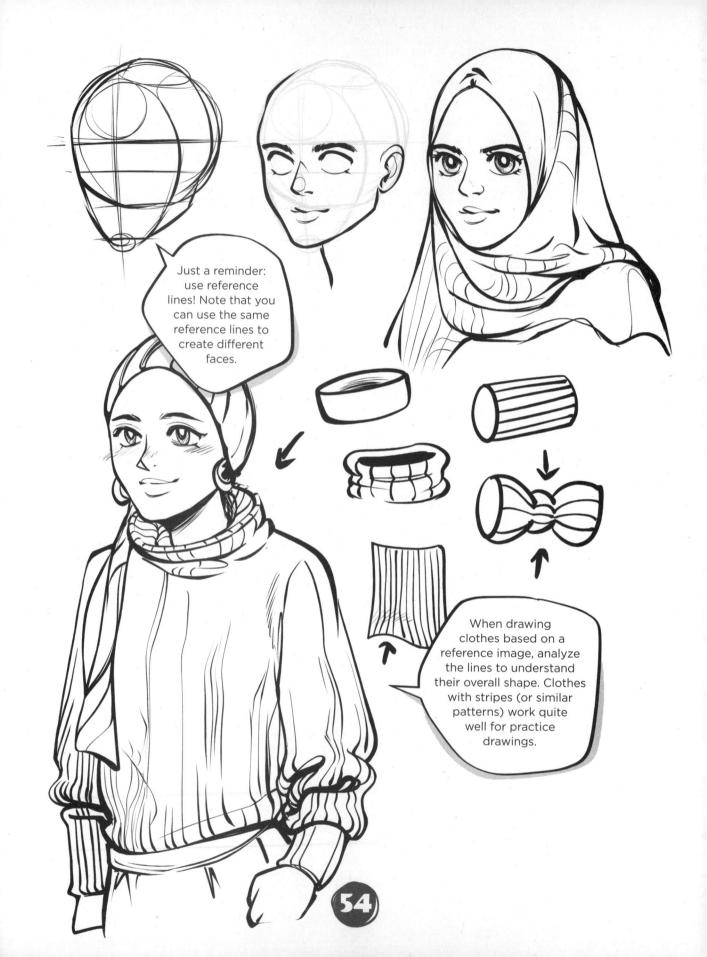

Just a reminder: use reference lines! Note that you can use the same reference lines to create different faces.

When drawing clothes based on a reference image, analyze the lines to understand their overall shape. Clothes with stripes (or similar patterns) work quite well for practice drawings.

54

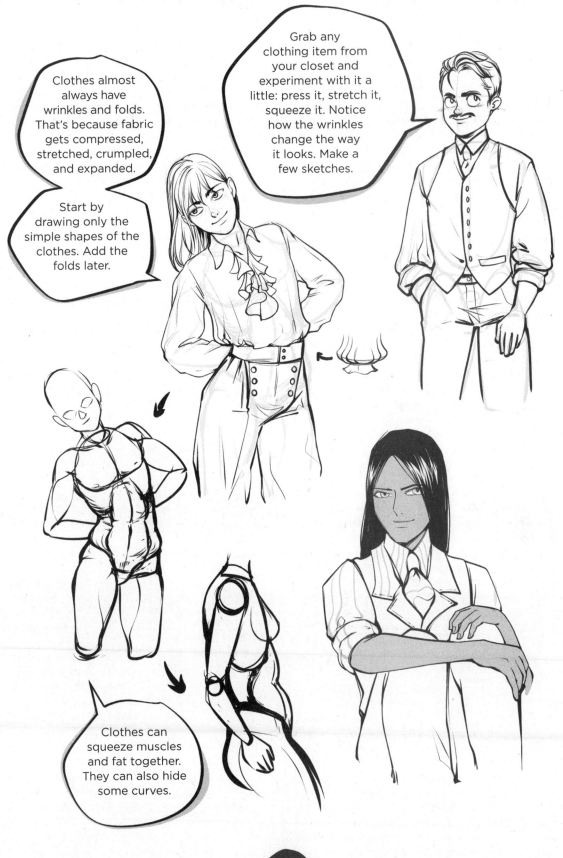

Clothes almost always have wrinkles and folds. That's because fabric gets compressed, stretched, crumpled, and expanded.

Grab any clothing item from your closet and experiment with it a little: press it, stretch it, squeeze it. Notice how the wrinkles change the way it looks. Make a few sketches.

Start by drawing only the simple shapes of the clothes. Add the folds later.

Clothes can squeeze muscles and fat together. They can also hide some curves.

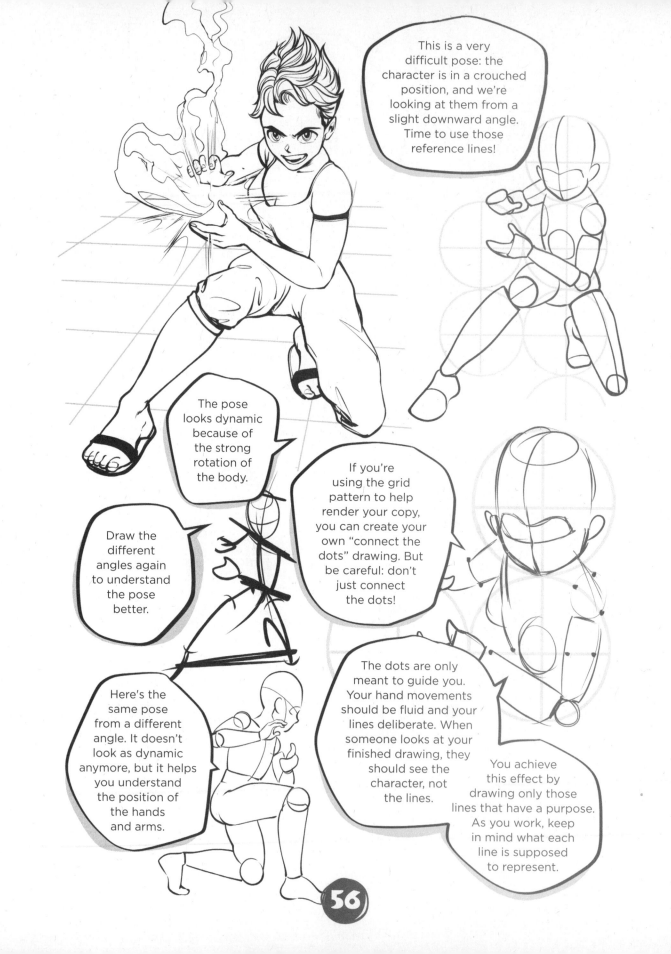

This is a very difficult pose: the character is in a crouched position, and we're looking at them from a slight downward angle. Time to use those reference lines!

The pose looks dynamic because of the strong rotation of the body.

Draw the different angles again to understand the pose better.

If you're using the grid pattern to help render your copy, you can create your own "connect the dots" drawing. But be careful: don't just connect the dots!

Here's the same pose from a different angle. It doesn't look as dynamic anymore, but it helps you understand the position of the hands and arms.

The dots are only meant to guide you. Your hand movements should be fluid and your lines deliberate. When someone looks at your finished drawing, they should see the character, not the lines.

You achieve this effect by drawing only those lines that have a purpose. As you work, keep in mind what each line is supposed to represent.

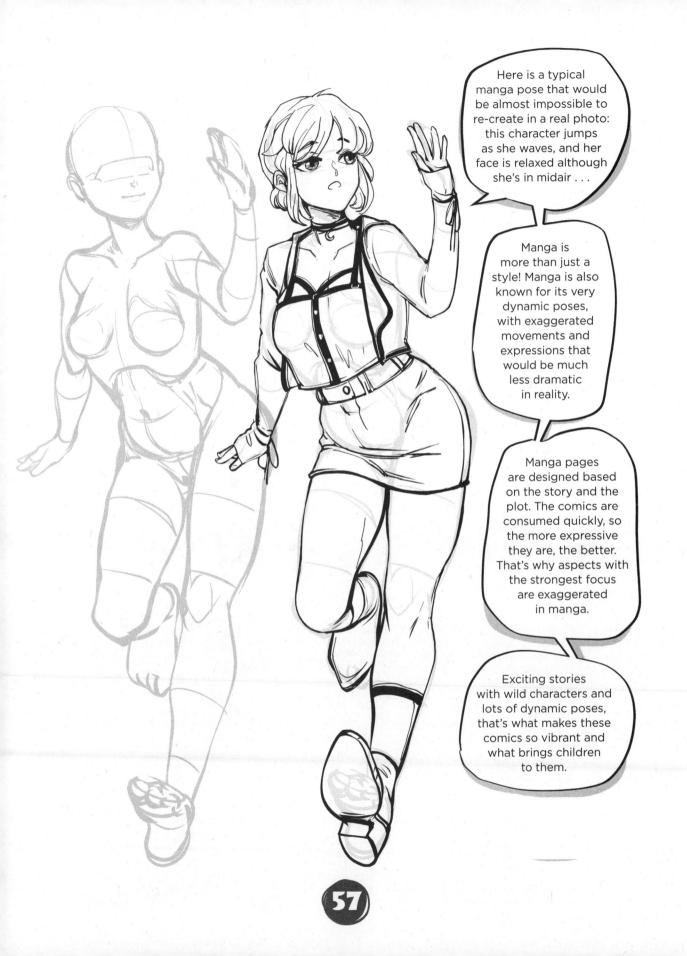

Here is a typical manga pose that would be almost impossible to re-create in a real photo: this character jumps as she waves, and her face is relaxed although she's in midair . . .

Manga is more than just a style! Manga is also known for its very dynamic poses, with exaggerated movements and expressions that would be much less dramatic in reality.

Manga pages are designed based on the story and the plot. The comics are consumed quickly, so the more expressive they are, the better. That's why aspects with the strongest focus are exaggerated in manga.

Exciting stories with wild characters and lots of dynamic poses, that's what makes these comics so vibrant and what brings children to them.

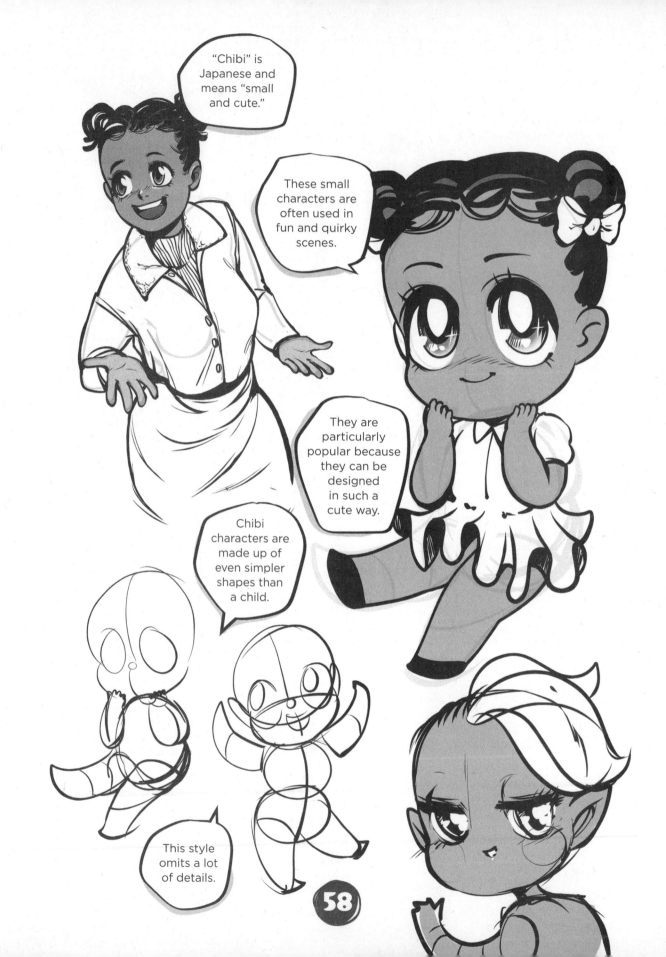

"Chibi" is Japanese and means "small and cute."

These small characters are often used in fun and quirky scenes.

They are particularly popular because they can be designed in such a cute way.

Chibi characters are made up of even simpler shapes than a child.

This style omits a lot of details.

58

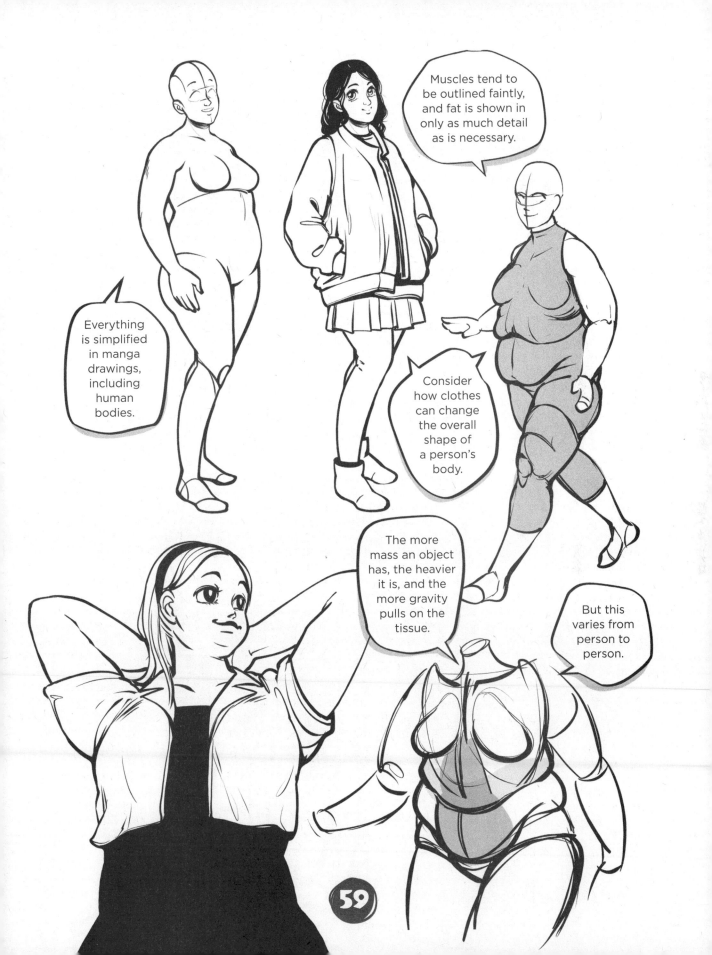

Muscles tend to be outlined faintly, and fat is shown in only as much detail as is necessary.

Everything is simplified in manga drawings, including human bodies.

Consider how clothes can change the overall shape of a person's body.

The more mass an object has, the heavier it is, and the more gravity pulls on the tissue.

But this varies from person to person.

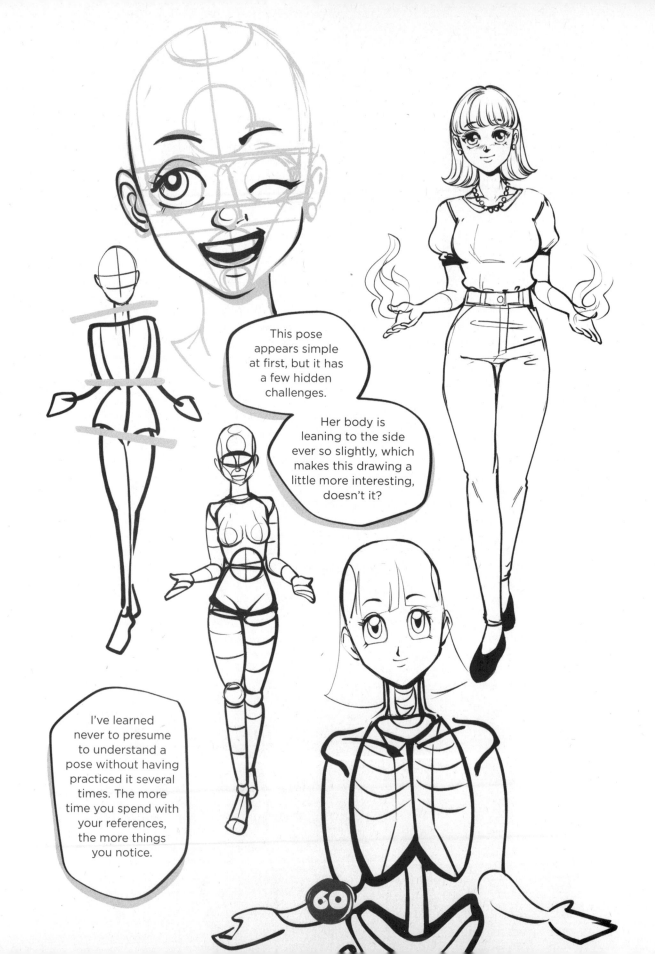

This pose appears simple at first, but it has a few hidden challenges.

Her body is leaning to the side ever so slightly, which makes this drawing a little more interesting, doesn't it?

I've learned never to presume to understand a pose without having practiced it several times. The more time you spend with your references, the more things you notice.

60

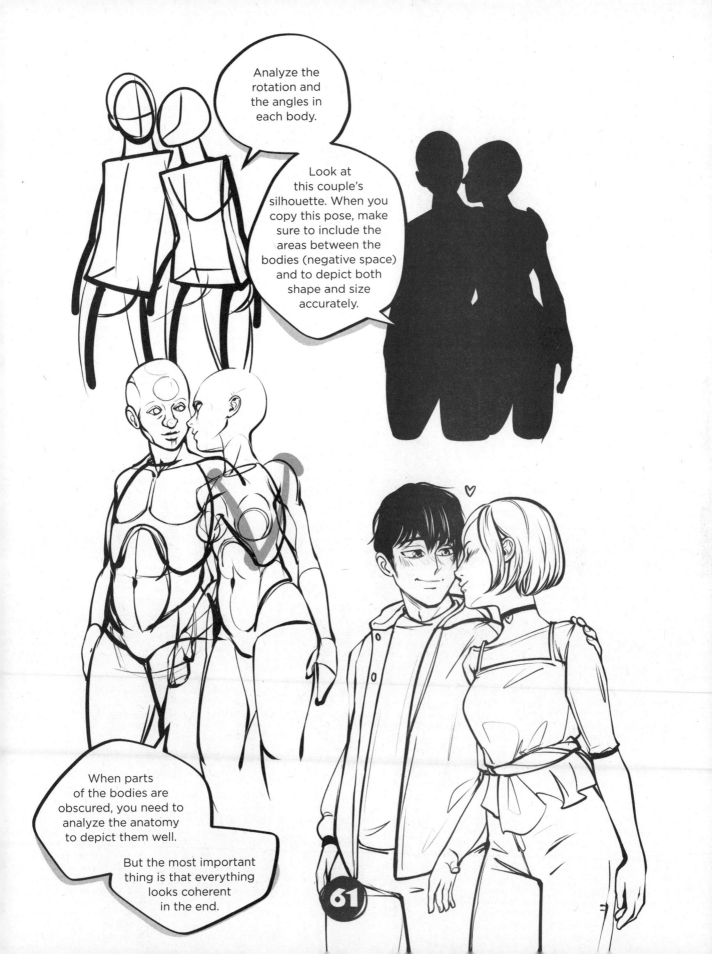

Analyze the rotation and the angles in each body.

Look at this couple's silhouette. When you copy this pose, make sure to include the areas between the bodies (negative space) and to depict both shape and size accurately.

When parts of the bodies are obscured, you need to analyze the anatomy to depict them well.

But the most important thing is that everything looks coherent in the end.

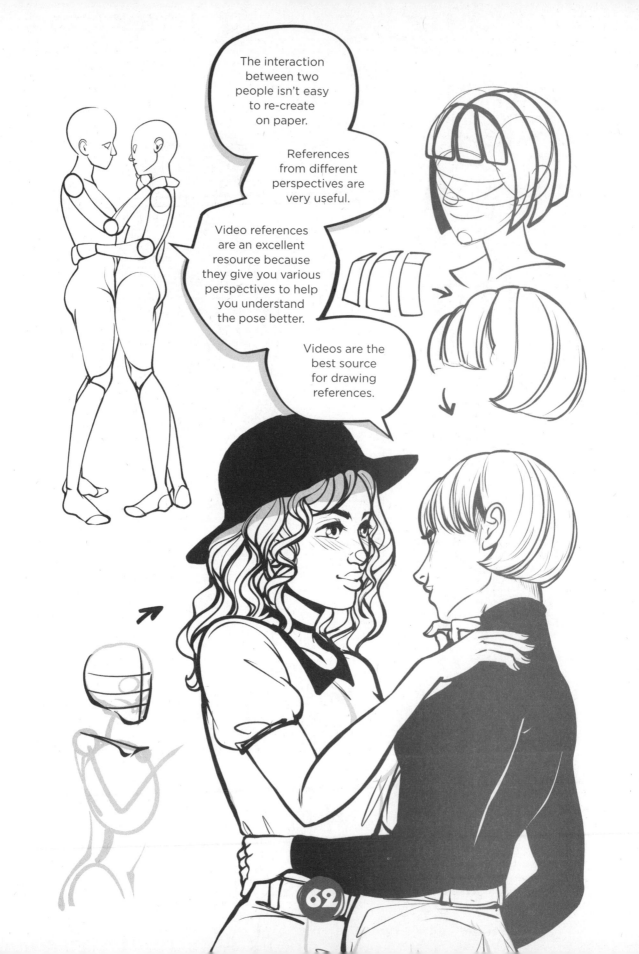

The interaction between two people isn't easy to re-create on paper.

References from different perspectives are very useful.

Video references are an excellent resource because they give you various perspectives to help you understand the pose better.

Videos are the best source for drawing references.

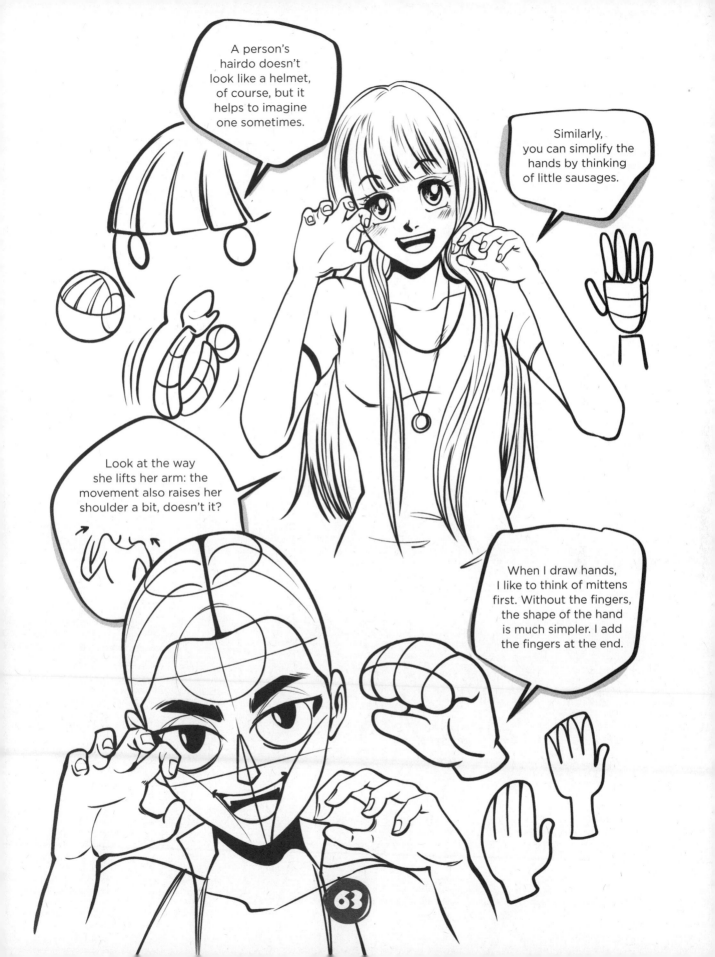

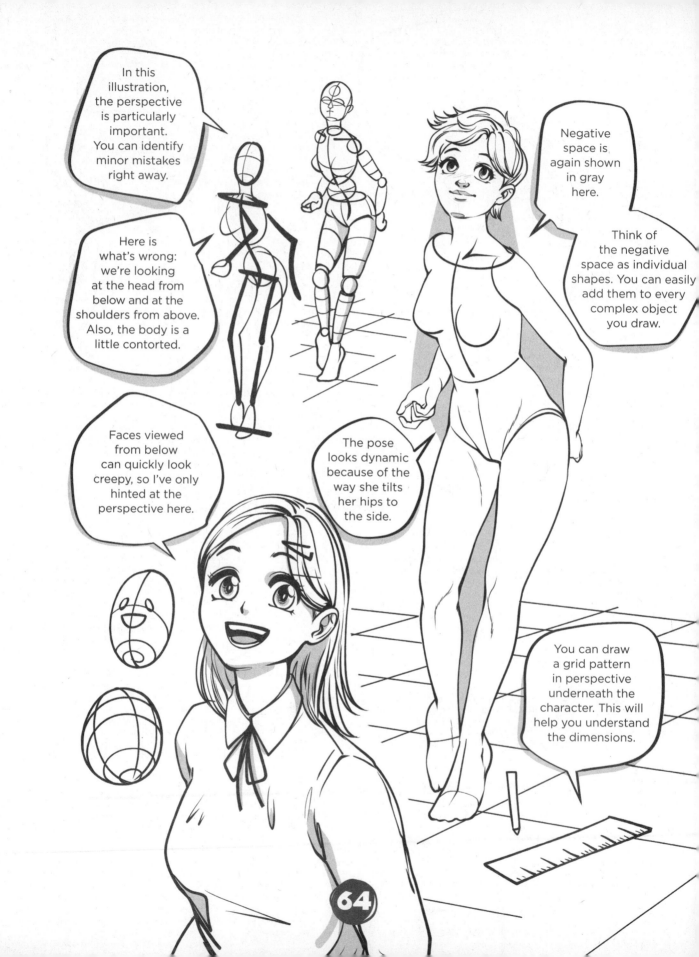

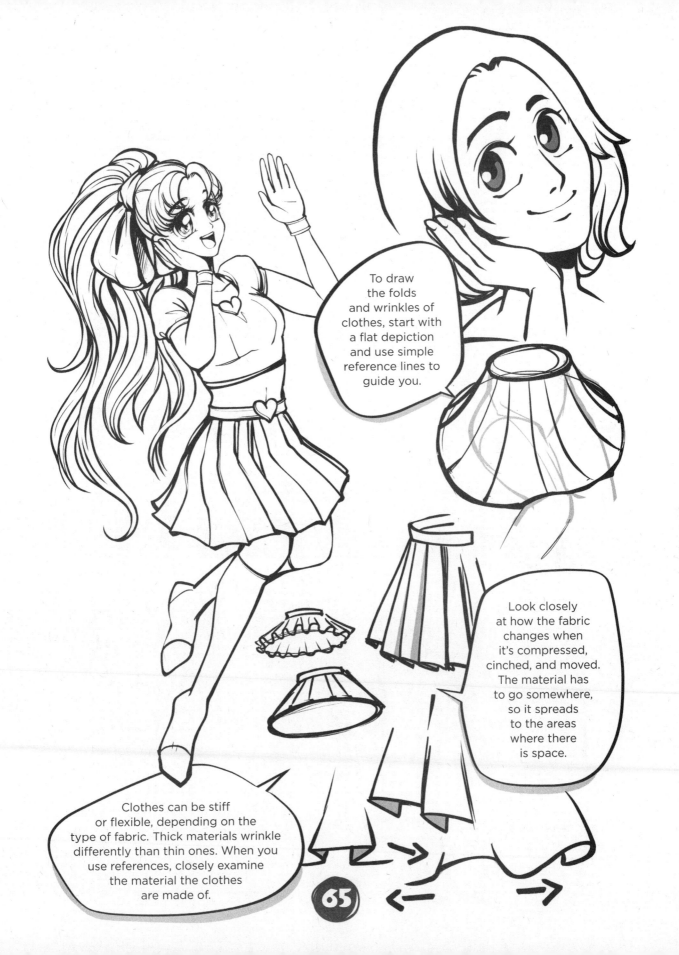

To draw the folds and wrinkles of clothes, start with a flat depiction and use simple reference lines to guide you.

Look closely at how the fabric changes when it's compressed, cinched, and moved. The material has to go somewhere, so it spreads to the areas where there is space.

Clothes can be stiff or flexible, depending on the type of fabric. Thick materials wrinkle differently than thin ones. When you use references, closely examine the material the clothes are made of.

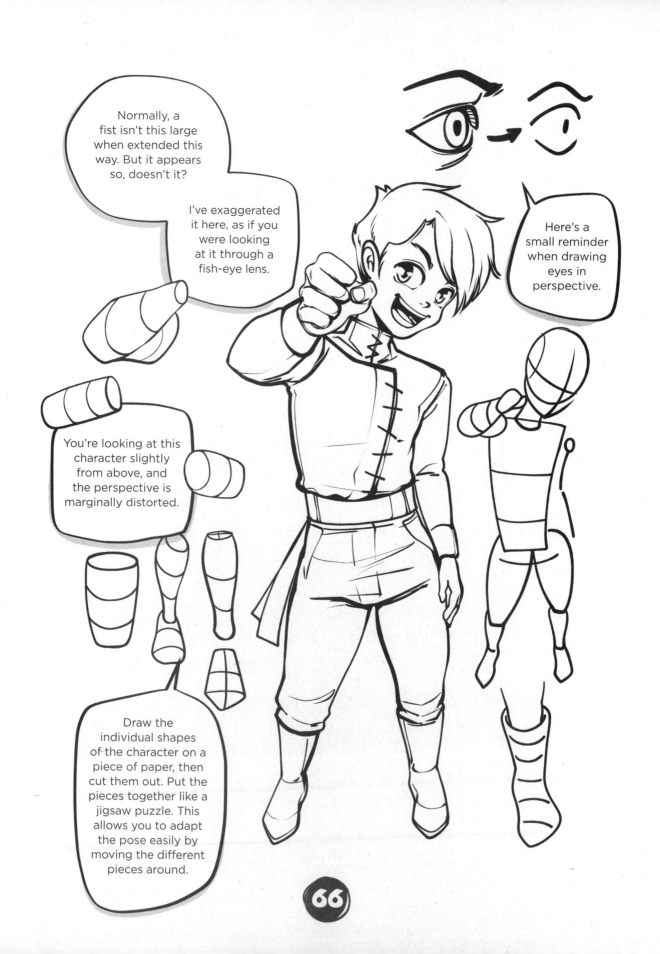

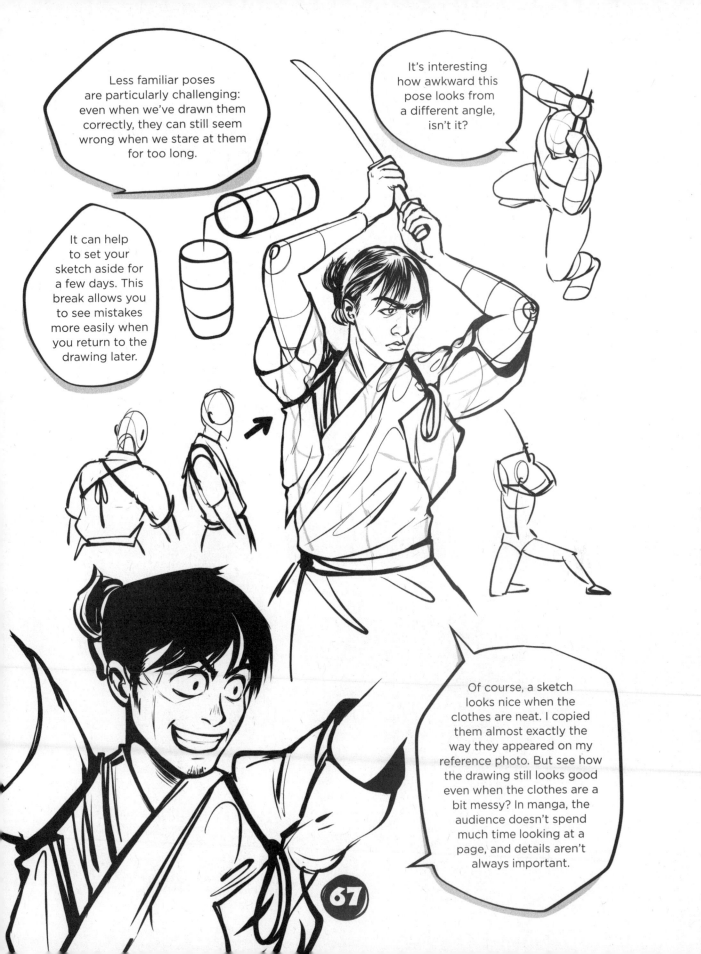

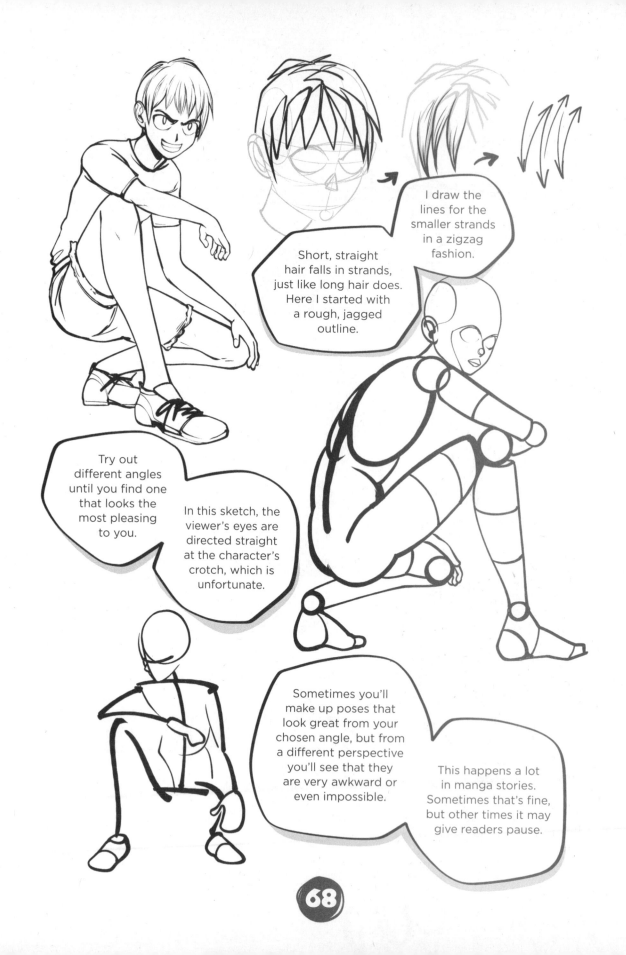

I draw the lines for the smaller strands in a zigzag fashion.

Short, straight hair falls in strands, just like long hair does. Here I started with a rough, jagged outline.

Try out different angles until you find one that looks the most pleasing to you.

In this sketch, the viewer's eyes are directed straight at the character's crotch, which is unfortunate.

Sometimes you'll make up poses that look great from your chosen angle, but from a different perspective you'll see that they are very awkward or even impossible.

This happens a lot in manga stories. Sometimes that's fine, but other times it may give readers pause.

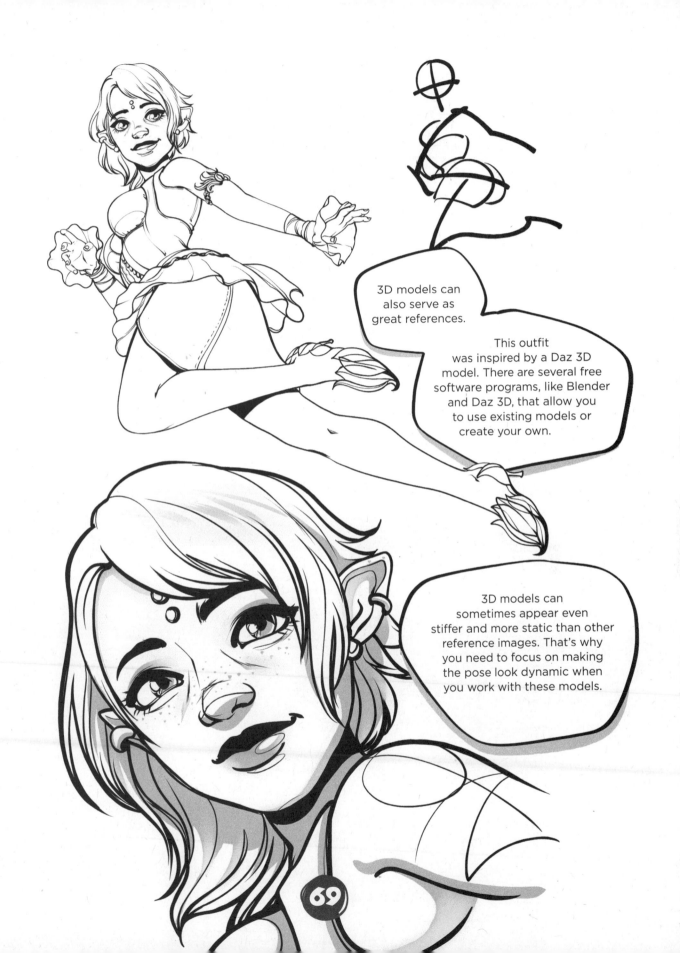

3D models can also serve as great references.

This outfit was inspired by a Daz 3D model. There are several free software programs, like Blender and Daz 3D, that allow you to use existing models or create your own.

3D models can sometimes appear even stiffer and more static than other reference images. That's why you need to focus on making the pose look dynamic when you work with these models.

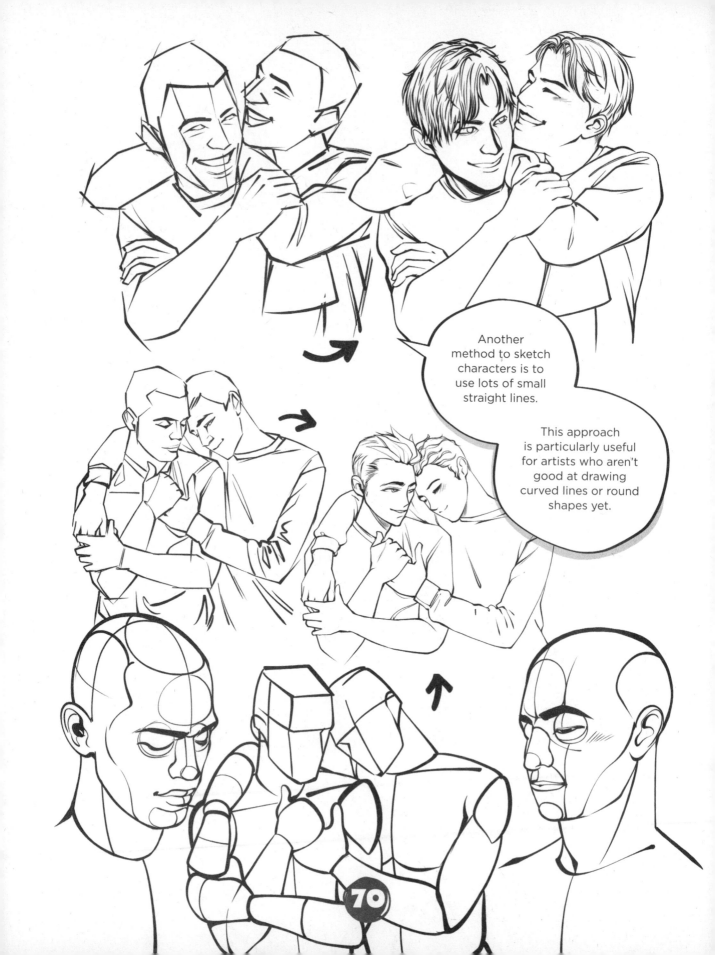

Another method to sketch characters is to use lots of small straight lines.

This approach is particularly useful for artists who aren't good at drawing curved lines or round shapes yet.

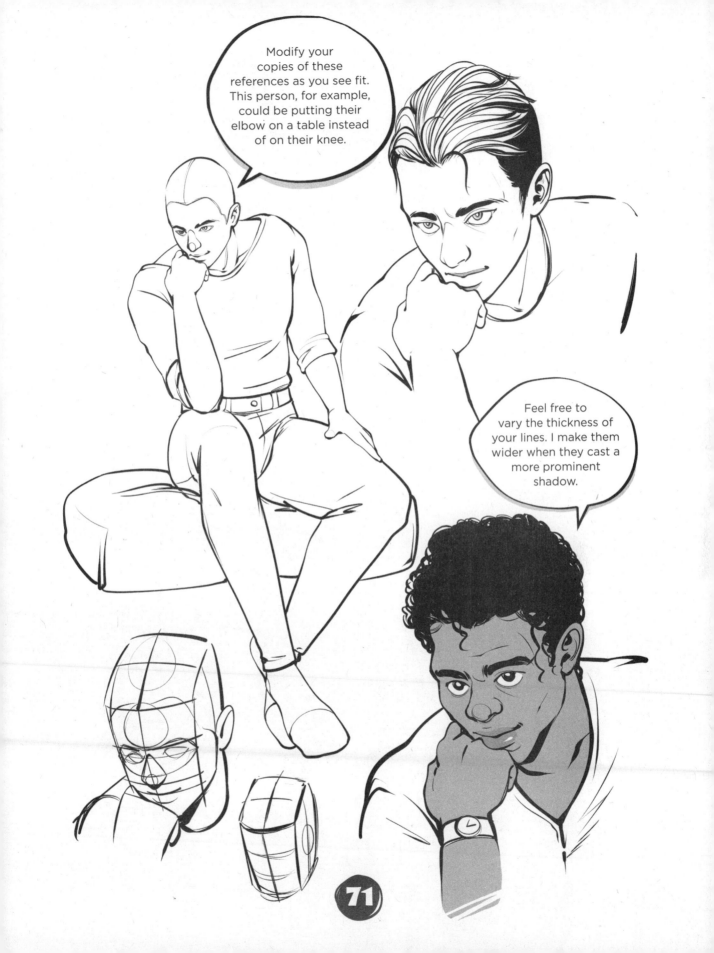

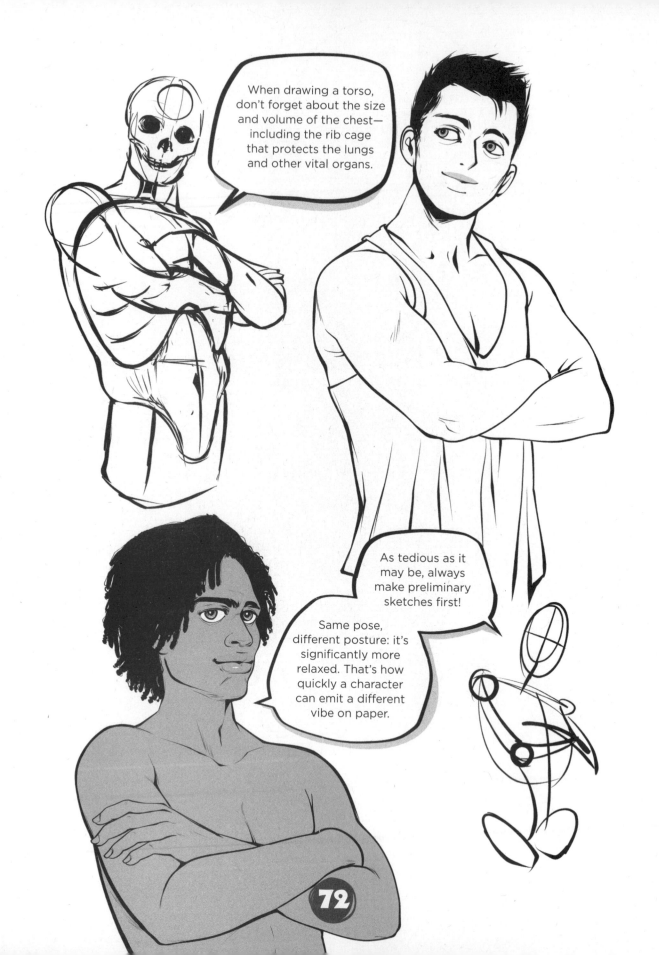

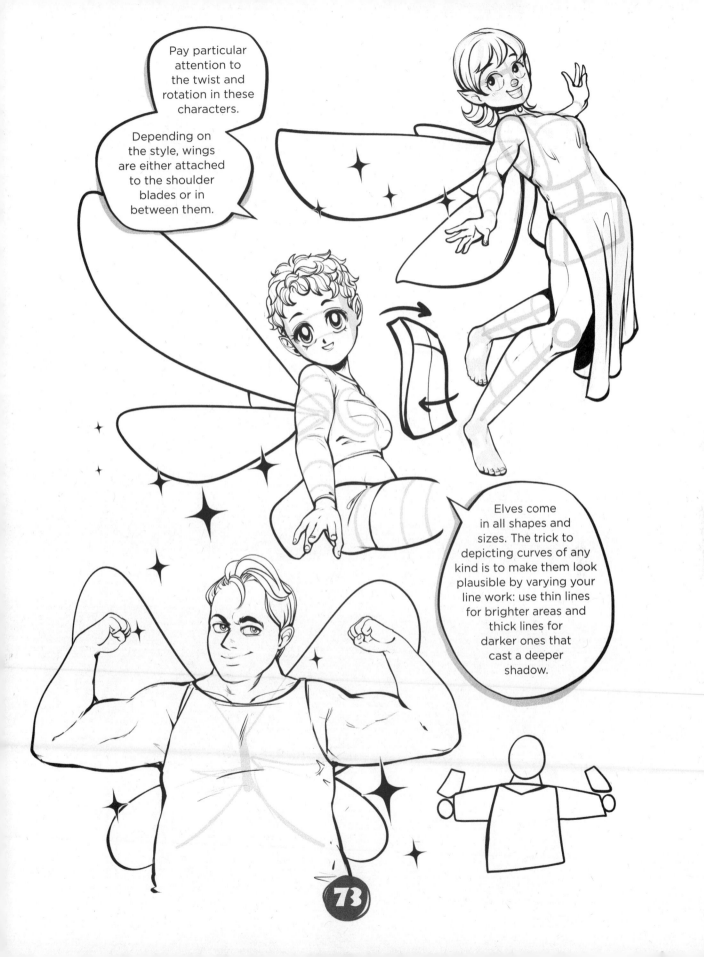

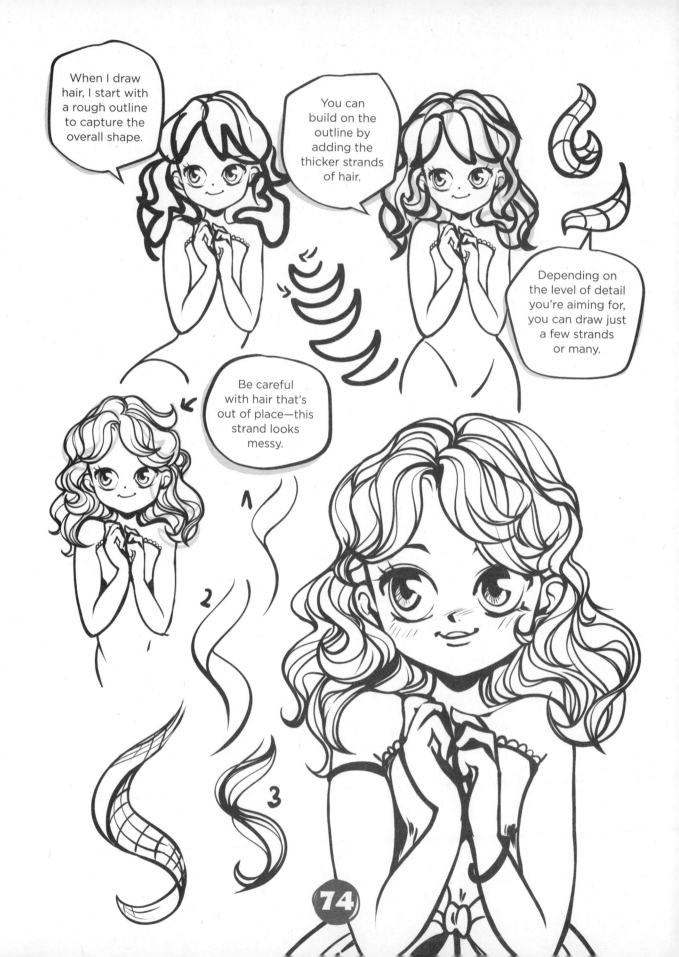

When I draw hair, I start with a rough outline to capture the overall shape.

You can build on the outline by adding the thicker strands of hair.

Depending on the level of detail you're aiming for, you can draw just a few strands or many.

Be careful with hair that's out of place—this strand looks messy.

74

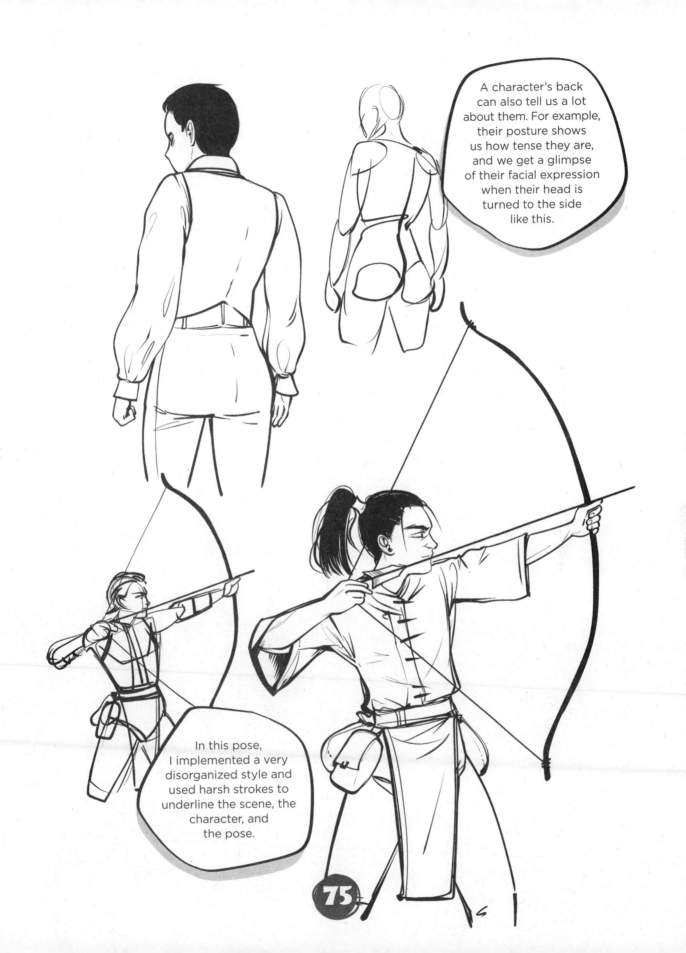

A character's back can also tell us a lot about them. For example, their posture shows us how tense they are, and we get a glimpse of their facial expression when their head is turned to the side like this.

In this pose, I implemented a very disorganized style and used harsh strokes to underline the scene, the character, and the pose.

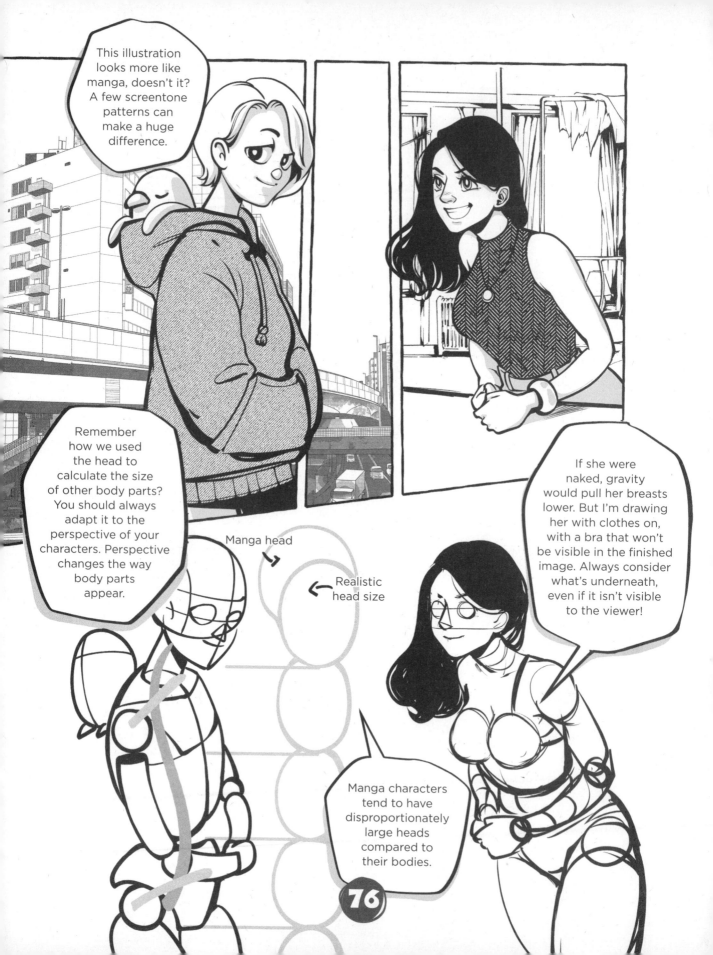

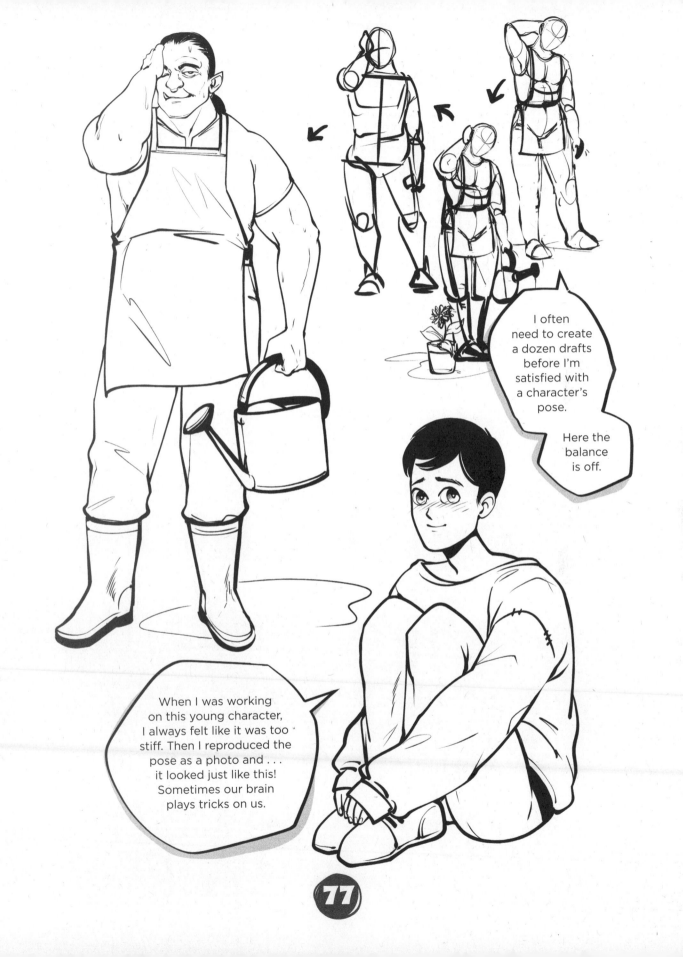

I often need to create a dozen drafts before I'm satisfied with a character's pose.

Here the balance is off.

When I was working on this young character, I always felt like it was too stiff. Then I reproduced the pose as a photo and . . . it looked just like this! Sometimes our brain plays tricks on us.

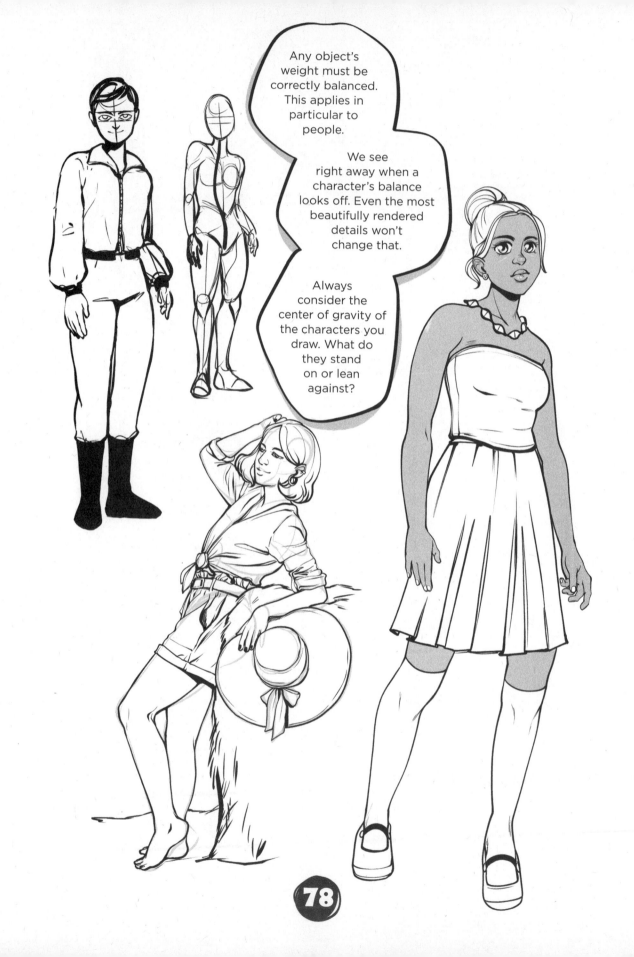

Any object's weight must be correctly balanced. This applies in particular to people.

We see right away when a character's balance looks off. Even the most beautifully rendered details won't change that.

Always consider the center of gravity of the characters you draw. What do they stand on or lean against?

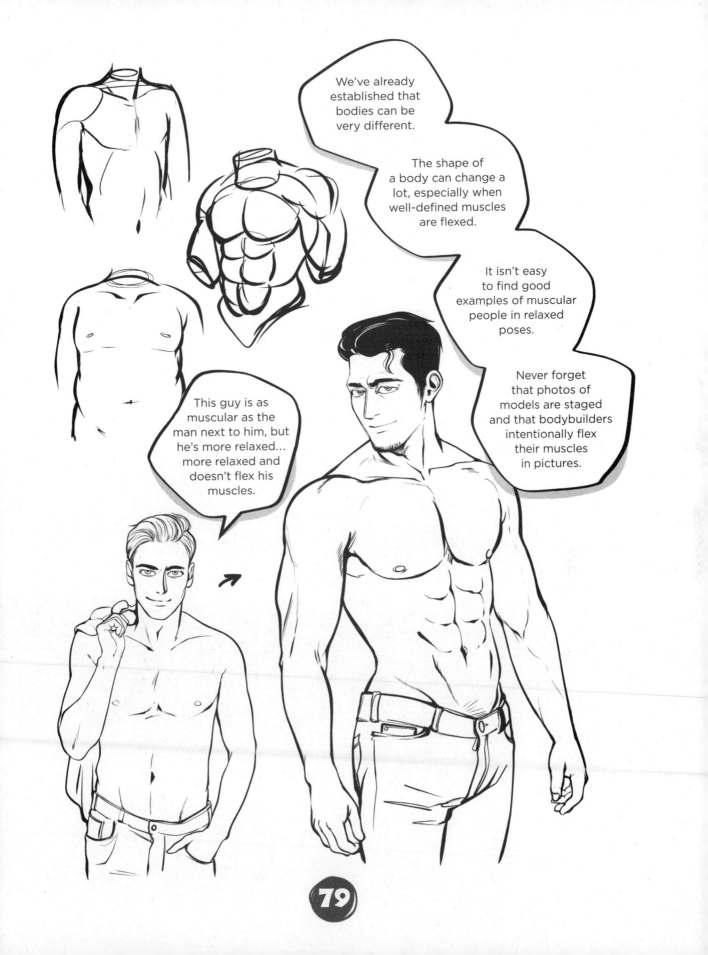

We've already established that bodies can be very different.

The shape of a body can change a lot, especially when well-defined muscles are flexed.

It isn't easy to find good examples of muscular people in relaxed poses.

Never forget that photos of models are staged and that bodybuilders intentionally flex their muscles in pictures.

This guy is as muscular as the man next to him, but he's more relaxed... more relaxed and doesn't flex his muscles.

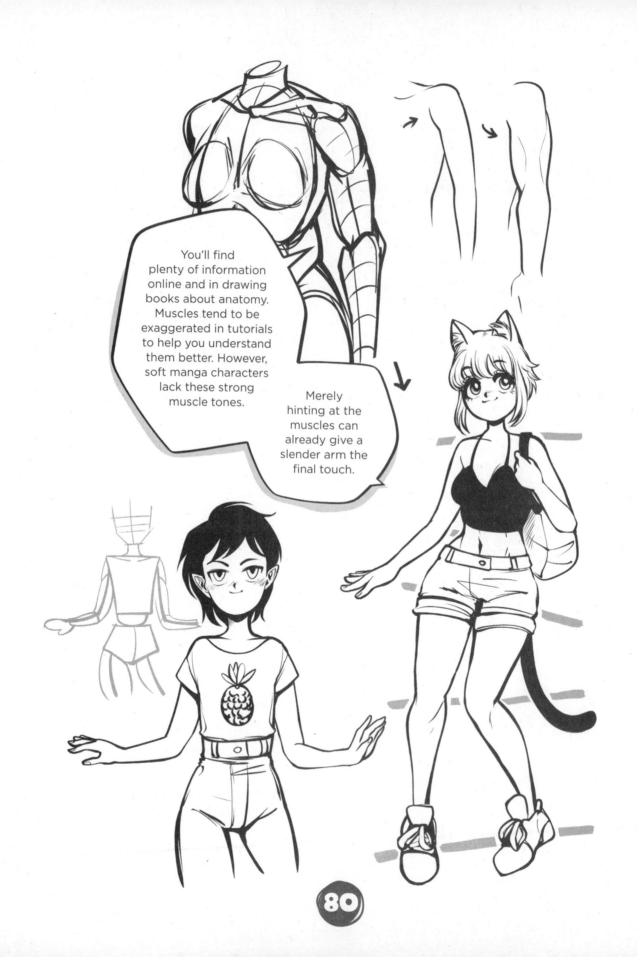

You'll find plenty of information online and in drawing books about anatomy. Muscles tend to be exaggerated in tutorials to help you understand them better. However, soft manga characters lack these strong muscle tones.

Merely hinting at the muscles can already give a slender arm the final touch.

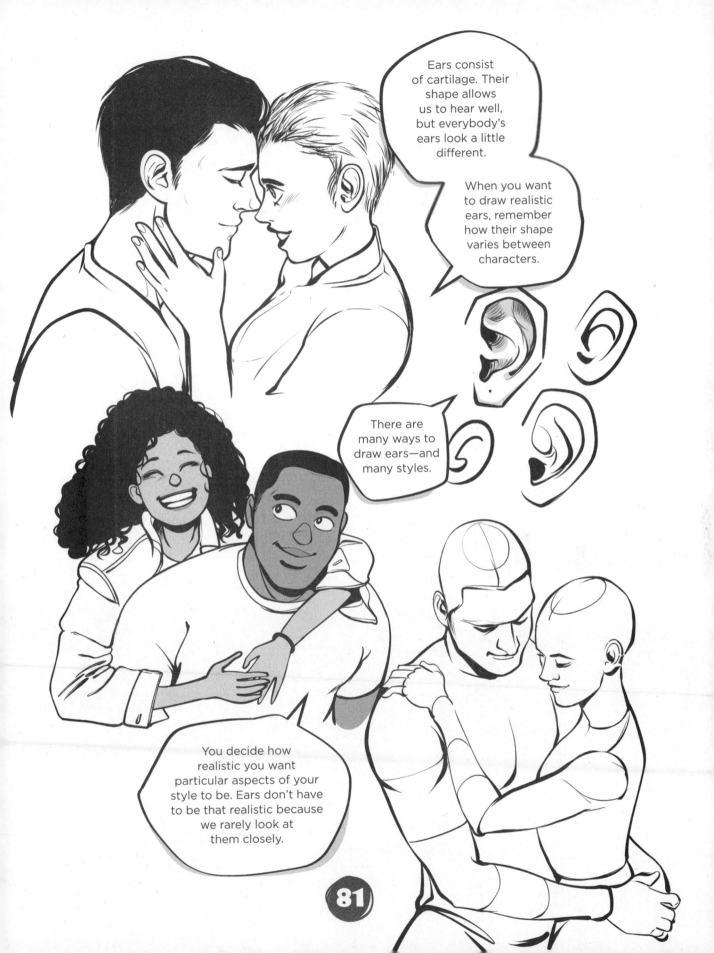

Ears consist of cartilage. Their shape allows us to hear well, but everybody's ears look a little different.

When you want to draw realistic ears, remember how their shape varies between characters.

There are many ways to draw ears—and many styles.

You decide how realistic you want particular aspects of your style to be. Ears don't have to be that realistic because we rarely look at them closely.

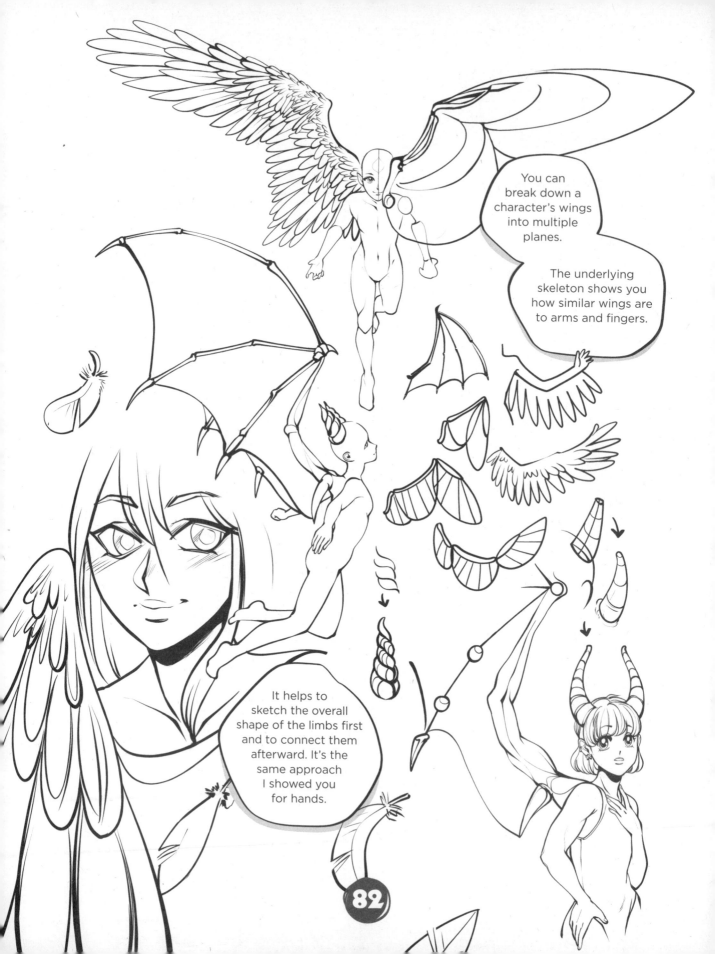

You can break down a character's wings into multiple planes.

The underlying skeleton shows you how similar wings are to arms and fingers.

It helps to sketch the overall shape of the limbs first and to connect them afterward. It's the same approach I showed you for hands.

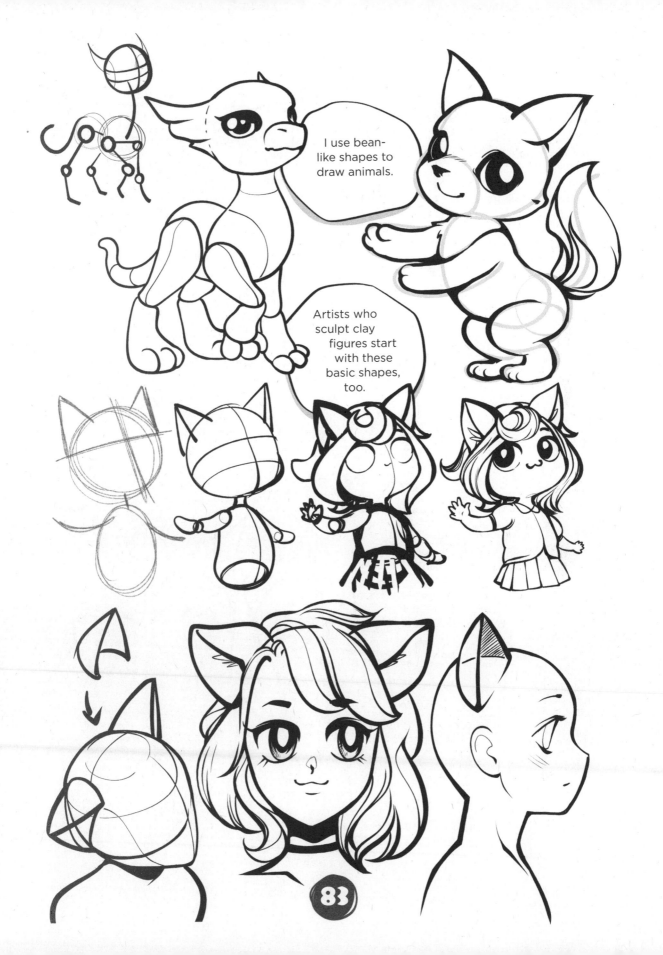

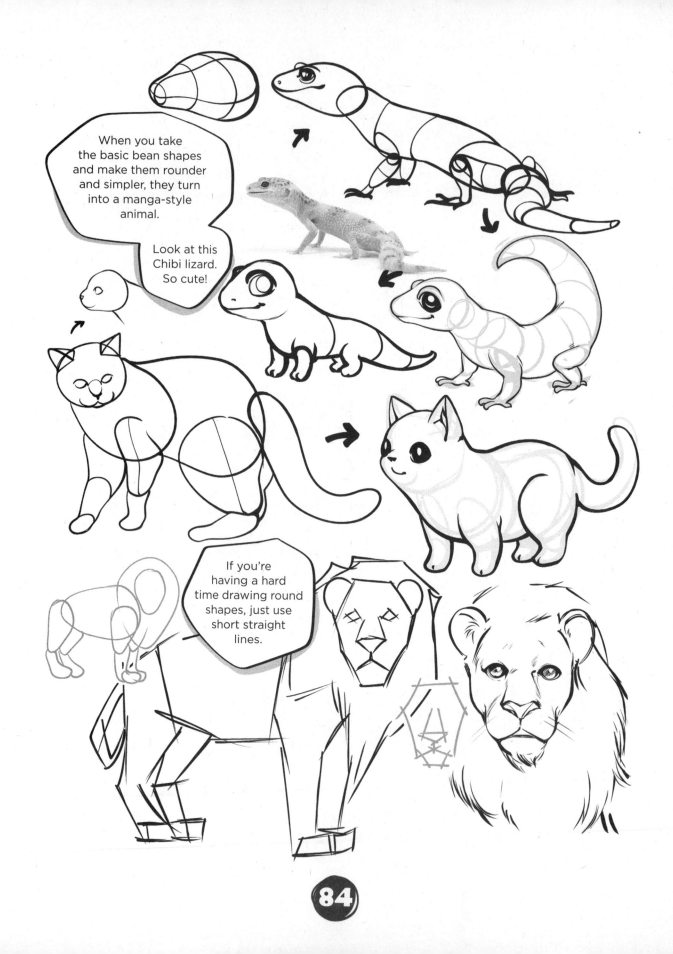

When you take the basic bean shapes and make them rounder and simpler, they turn into a manga-style animal.

Look at this Chibi lizard. So cute!

If you're having a hard time drawing round shapes, just use short straight lines.

CHAPTER 5
THE PRINCIPLES OF MANGA

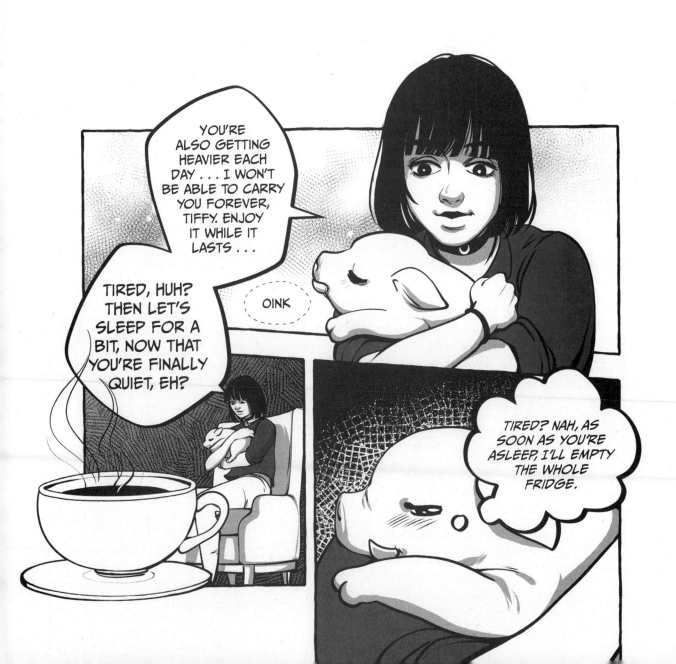

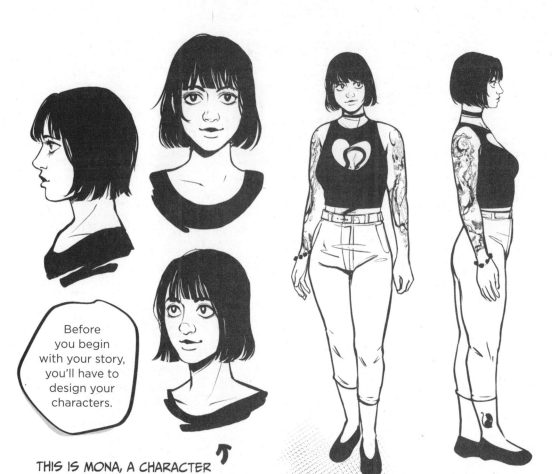

Before you begin with your story, you'll have to design your characters.

THIS IS MONA, A CHARACTER FROM MY BOOKS.

Every manga book starts with a story, and every story consists of characters and a plot. Most of the time, the characters need to solve several problems. You create suspense by showing the reader how your characters reach their goals. The achievements and setbacks in the story make the reader relate to your characters.

So, drawing manga means that you need to be able to write stories in addition to knowing how to draw. That's a whole different topic, but I can give you one tip: everything in the story needs to make sense.

Always ask yourself these questions: Does this advance the plot? Is it important for the character development? Is this scene entertaining?

You may use Mona for practice, but her design is mine. By design I mean the combination of her style and look (for example, her tattoos), her name, and her story. It's important that you respect the intellectual property of others.

Just like all characters you create belong to you.

86

Let's start with the setup. How do we tell a story in panels? A clear arrangement of your panels is crucial. Using the same spacing can be helpful to create a basic structure and layout.

Mangas tell stories through images, text, and sound words. Each story has its own narrative and style.

I make the horizontal spacing larger than the vertical one. I don't deviate from this spatial arrangement, with a few minor exceptions.

Sometimes the design has to be modified slightly to make the scene work better.

Speech bubbles can extend beyond the panel frame. You can even make panels look like they extend beyond the page.

Not everything has to line up perfectly. Skewed panels increase the pacing in the story.

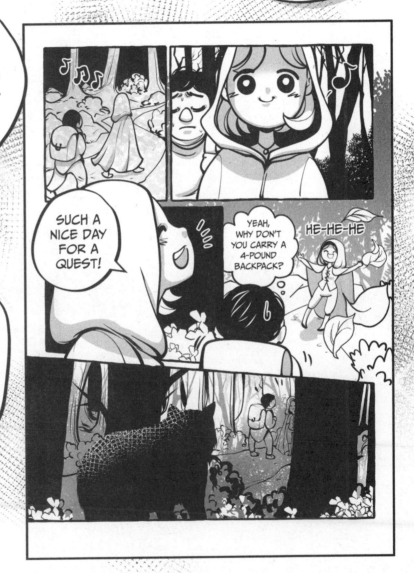

SUCH A NICE DAY FOR A QUEST!

YEAH, WHY DON'T YOU CARRY A 4-POUND BACKPACK?

HE-HE-HE

It takes a lot of design knowledge to create manga pages. There's so much to learn about the layout alone that the topic would fill another book. But just approach the design challenge the same way you're learning to draw manga: by studying what others are doing and by practicing.

Get yourself the appropriate tools right at the beginning. If you want to work with paper, you'll need good rulers and many brush pens, perhaps even a fountain pen and some ink.

Nowadays, I tend to recommend digital tools to create manga drawings. You'll need a tablet, such as an iPad or a Galaxy Note, with a stylus (drawing pen). There are drawing tablets and pen displays for desktop computers—for example, by Wacom, Huion, and Artisul. These tools allow you to use a digital pen to draw on the screen. Programs such as Clip Studio Paint (Windows, macOS, iOS, Android), but also Procreate (iOS), Infinite Painter (Android, iOS), Krita (Windows, macOS), Paint Tool SAI (Windows, macOS), and even Photoshop (Windows, macOS, iOS, Android) provide plenty of tools that can help you tell beautiful manga stories.

Artists tend to use many references, especially in manga. Tools to draw poses, such as Design Doll (Windows) or even the integrated tool for poses by Clip Studio Paint, allow you to work much more efficiently. The saying "work smarter, not harder" applies to manga, too!

Stories require planning, so take some time before you sit down to draw.

It all starts with your idea. I strongly advise you to plot your manga story first.

What is a plot? It's the foundation of every story. Write down what happens from beginning to end so you don't forget any details. Make sure to include all important events.

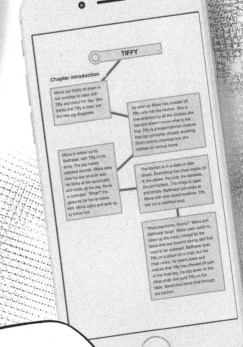

Divide a large sheet of paper into several smaller manga pages and use the margins to jot down what happens—for example, the dialogue and important plot details.

Then you can start to make rough sketches of your scenes—just like for a movie storyboard.

As you sketch, you may have to modify your initial plan for the story. Visual and narrative stories are quite different from one another.

Through trial and error, you'll learn a lot and find your own approach.

MONA
CHAPTER I

Mona should look tired

Time passes

Tiffy goes into the kitchen and is happy

How much space you devote to your scenes depends on how important they are and how much detail you need to include so the reader can follow the story.

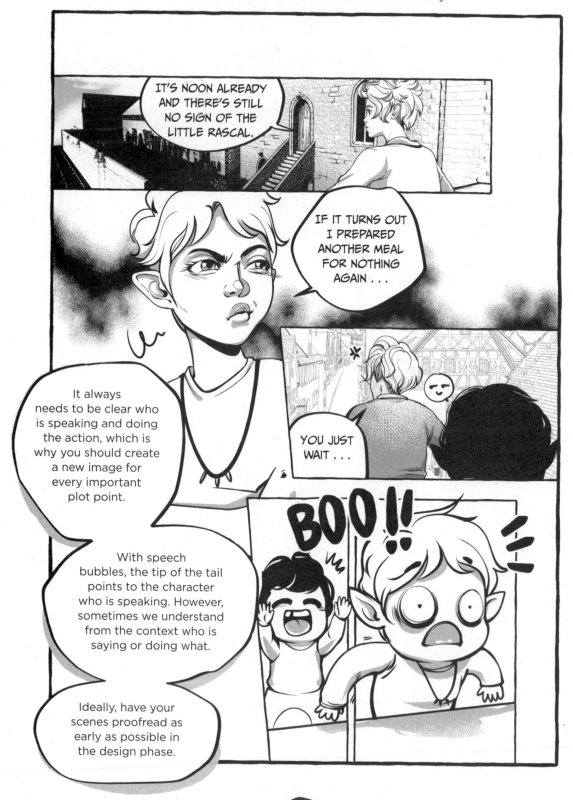

In your story drafts, indicate the reading direction and ensure that it's clear from your layout. Horizontal panels are viewed in the order in which they appear in that row.

We read from left to right, in horizontal rows from top to bottom.

(Traditional Japanese comics are read from right to left.)

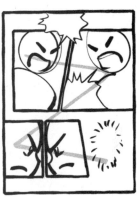

That's why there are larger gaps between vertically stacked panels.

This layout and panel arrangement guides the eye automatically from left to right.

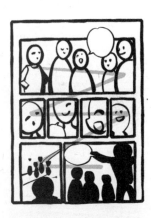

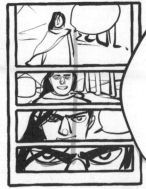

Sketchbooks aren't meant only for sketches. If you see a manga layout you like, note it for later.

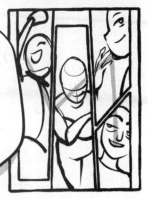

This is the process I use to design my panel page layout.

I start with a quick sketch and include the panel layout and texts.

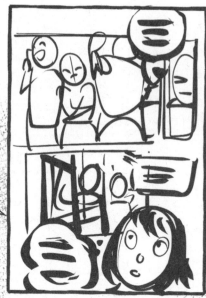

SPEECH BUBBLE 1: OH MAAAAN, HOW I'D LIKE TO CAST A SPELL AND MAKE THEM ALL GO AWAY RIGHT NOW!

TEXT BOX 1: NEXT STOP: CENTRAL STATION.

ZOMBIES: OUUUUUT, OUUUUUT

SPEECH BUBBLE 2: YES, PLEASE, GET OFF, EVERYONE . . . I DON'T FEEL LIKE SQUEEZING PAST YOU ZOMBIES . . .

I look for references right away and use them to improve my drafts.

Here's what a more advanced draft of mine looks like.

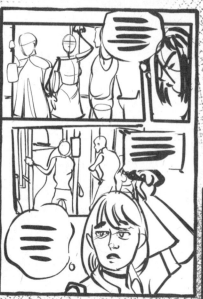

These are the reference images I used.

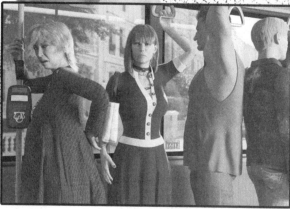

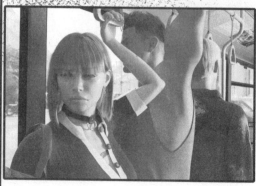

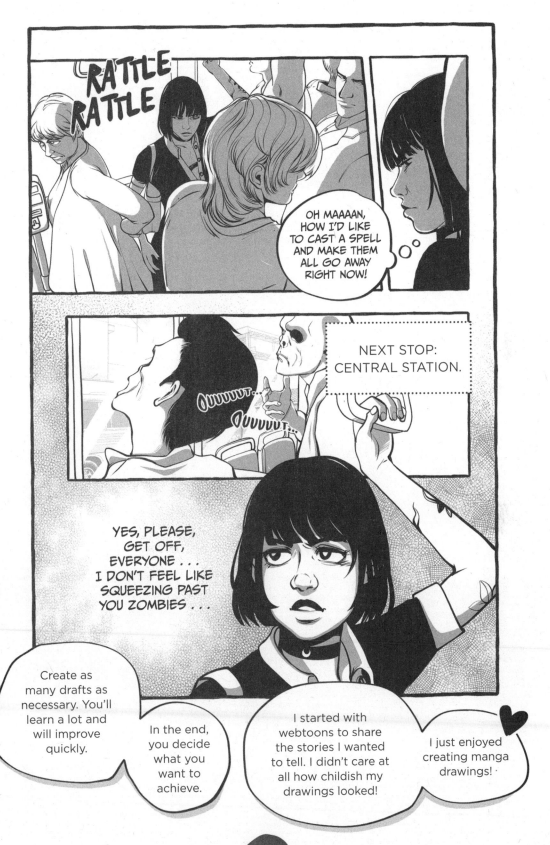

THANK YOU FOR YOUR PATIENCE.

We've reached the end of the book. I hope you
liked the many examples and references I shared
and that they have inspired you to pick up a
pen and create your own manga stories.

You can also find me on YouTube,
Twitch, Instagram, and TikTok:

kritzelpixel.de/linktree
patreon.com/KritzelPixel

I'd like to thank my community for watching
this book take shape in my many streams
and for providing helpful feedback.

"Learn to Draw Manga" by KritzelPixel was first published in 2023 under the title "Manga Zeichnen Lernen Mit Spaß" by Yuna, an imprint of Penguin Random House Verlagsgruppe GmbH, Munich, Germany.

Images and references by:
envato elements (twenty20photos, seventyfourimages, PetlinDmitry, ndanko, tommyandone, karandaev, Fasci, nikki_meel, OksaLy, sofiiashunkina, willmilne, artfotodima, insidecreativehouse, vadymvdrobot, arthurhidden, fotorince, Ann_Mishel, 918Evgenij, Masson-Simon, 918Evgenij, friends_stock, iuliia_n, leikapro, BGStock72, PixelSquid360, Daniel_Dash, ASphotostudio, CarlosBarquero, heckmannoleg, wayhomestudioo, kiraliffe, bublikhaus, arthurhidden, kiraliffe, valeriygoncharukphoto, DC_Studio, ametov41, ebelodedova, scopioimages, claudioventrella, Wavebreakmedia, cristi180884, Satura_, master1305, ADDICTIVE_STOCK, nattanartp, oneinchpunchphotos, fxquadro, Rawpixel, Nataliantalia)
· daz3D assets (Gustef, 3D Sugar, maelwenn, Propschick, Matari3D, Anna Benjamin, Mada, midnight_stories, Dogz, Fred Winkler Art, Sabby, PedroFurtadoArts, RawArt, WindField, Sixus1 Media, Mytilus, 3dLab, HM, Crocodile Liu, Barbara Brundon, Shox-Design, Umblefugly, Sade, Moonscape Graphics, GolaM, Lady Littlefox)

Book design and cover design by Isabel Zimmermann
English translation by Christina Stinn
English Edit by Angelica Martinez

Printed in the United States of America
1st Printing

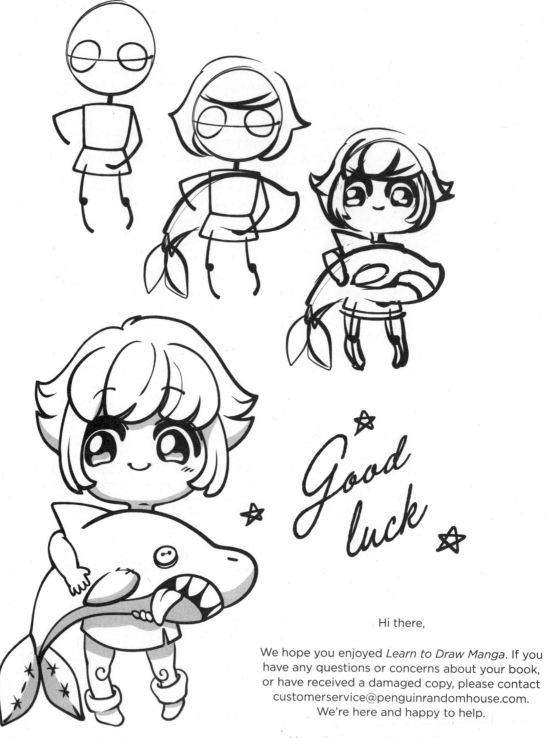

Good luck

Hi there,

We hope you enjoyed *Learn to Draw Manga*. If you have any questions or concerns about your book, or have received a damaged copy, please contact customerservice@penguinrandomhouse.com. We're here and happy to help.

Also, please consider writing a review on your favorite retailer's website to let others know what you thought of the book!

Sincerely,
The Zeitgeist Team